Annemarie Vels Heijn

# Rembrandt

Scala Books
Published in association with
the Rijksmuseum Foundation, Amsterdam

© 1989 Rijksmuseum, Amsterdam

First published in 1989 by
Scala Publications Ltd
3 Greek Street
London W1V 6NX

Distributed in the USA and Canada by
Rizzoli International Publications, Inc
300 Park Avenue South
New York
NY 10010

Translated from the Dutch by Alastair Weir
Text edited by Paul Holberton
Designed by Alan Bartram
Produced by Scala Publications Ltd
Filmset by August Filmsetting, St Helens, England
Printed and bound in Italy by Graphicom, Vicenza

ISBN 1 870248 21 X *hardback*
ISBN 1 870248 22 8 *paperback*
LC 88–062813

## Sources

Amsterdam, Rijksmuseum   3, 4, 5, 7, 8, 11, 18, 21, 23, 24, 29, 32, 42, 45, 46, 47, 54, 58
Amsterdam, Six Foundation   37
Boston, Museum of Fine Arts   6, 13, 14
Brunswick, Herzog Anton Ulrich Museum   59
Detroit, Institute of Arts   25
Dresden, Gemäldegalerie   15, 22, 27
The Hague, Mauritshuis   10, 55, 60
Kassel, Gemäldegalerie   33, 41
Leiden, Stedelijk Museum de Lakenhal   1
Leningrad, Hermitage   16, 19, 30, 31
London, Kenwood House, The Iveagh Bequest   50
London, National Gallery   26, 39, 51, 52, 56
Los Angeles, County Museum of Art   17
Los Angeles, The Armand Hammer Foundation   57
Munich, Alte Pinakothek   12
New York, The Frick Collection   9, 44
New York, Metropolitan Museum of Arts   35
Paris, Louvre   20, 36, 38
Rotterdam, Boymans-van Beuningen Museum   40
Stockholm, Nationalmuseum   53
Utrecht, Rijksmuseum Het Catharijneconvent   2
Vienna, Kunsthistorisches Museum   34
Washington, National Gallery of Art   48, 49
West Berlin, Staatliche Museen   28, 43

# Contents

# A Chronology for Rembrandt

**1606, 15 July**
Rembrandt born, the ninth of ten children and the son of a miller, Harmen van Rijn

**1613–20**
Rembrandt at school in the Latin school in Leiden

**1620**
Rembrandt enrolled in the University of Leiden

**1621–23**
Rembrandt serves his apprenticeship with minor painters in Leiden

**1624**
Rembrandt enters studio of Pieter Lastman in Amsterdam

**1625**
Rembrandt sets up in his own studio in Leiden

**1626**
Jan Lievens joins Rembrandt as a partner

**1628**
Gerard Dou, Rembrandt's first pupil, enters his studio in Leiden

**1629**
Constantijn Huygens, Secretary to the Stadtholder, visits Rembrandt and Jan Lievens

**1631**
Rembrandt moves to Amsterdam, entering Hendrick van Uylenburgh's art dealership

**1634, 22 July**
Rembrandt marries Saskia van Uylenburgh, Hendrick's niece, with a dowry of 4000 florins

**1634**
Rembrandt receives commissions from the Stadtholder Frederick Henry

**1635**
Rembrandt's first son, Rombertus, born, but dies in infancy

**1639**
Rembrandt and Saskia move to a large house in Sint Anthoniebreestraat

**1640**
Rembrandt's mother dies. Rembrandt has become a celebrated painter, perhaps the leading painter in Amsterdam

**1641**
Titus, Rembrandt and Saskia's only child to survive infancy, is born

**1642, 14 June**
Saskia dies probably of tuberculosis

**1642**
Rembrandt paints the *Night Watch*

**1649**
Geertje Dircx, having joined the household earlier, is expelled by Rembrandt and given a pension in an institution. Hendrickje Stoffels takes her place as Rembrandt's housekeeper and mistress

**1650**
Signs appear of stress in Rembrandt's financial circumstances

**1653**
Rembrandt is forced to borrow from friends in order to meet obligations in a time of general economic difficulty

**1654**
Denounced in church for living in sin with Hendrickje, who bears him a daughter, Cornelia, Rembrandt is in still greater difficulties with his creditors

**1656**
Rembrandt is finally made bankrupt. An inventory is drawn up of his goods

**1660**
Rembrandt receives praise from the leading Italian artist Guercino for his prints and paintings

**1660, 15 December**
Hendrickje and Titus form a company employing Rembrandt and selling his paintings for him. Three days later the trio set up house on the Rozenbracht in much diminished circumstances

**1663, 21 July**
Hendrickje dies

**1666**
Rembrandt attempts to buy a painting by Hans Holbein for 1000 florins

**1667, 29 December**
Prince Cosimo de' Medici visits 'the famous' Rembrandt among other Amsterdam painters

**1668**
Titus marries, but dies seven months later

**1669, 4 October**
Rembrandt dies

**1669, 8 October**
Rembrandt is buried in the Westerkerk, Amsterdam

# Introduction

Since Rembrandt is one of the best known, perhaps even the best known, painter in the world, it is surprising how little is known about him. Meticulous research through the archives has produced over the years a pile of documents in which Rembrandt is mentioned, or which have something to do with him, but these data tell us nothing, or almost nothing, about the man himself. They provide a few important facts about his paintings, but even these are much sparser than we would like.

The bare facts of Rembrandt's life are clear enough. He was born on 15th July 1606 in Leiden, the son of a miller. His promise was soon recognised, and at the age of 25 he was able to move to the capital, Amsterdam, and set up a flourishing 'practice', chiefly in portraits. In 1634 he married Saskia van Uylenburgh, and by 1639 was living in a large house in Sint Anthoniebreestraat. In 1641 Titus, their only child to survive beyond infancy, was born, and in 1642 his wife died. Successively two housekeepers, Geertje Dircx and Hendrickje Stoffels, lived with the painter and his son. During the 1650s debts began to mount up, and in 1656 Rembrandt had to petition for bankruptcy. He had to move to a smaller house, while Hendrickje and Titus set up as art dealers so Rembrandt could go on selling his work. In 1663 Hendrickje died, and Titus in 1668, seven months after he had married. Rembrandt himself died on 4th October 1669, at the age of 63.

To this rather troubled outline modern scholarship has been able to add comparatively little. Rather more striking progress, however, has been made as regards the paintings themselves. Not so long ago, nearly one thousand surviving works of art were believed to have been painted by Rembrandt. Today that figure has been enormously reduced, so that a fair estimate would be more like 300. Of those, there stand out certain key works – documented works, works that mark a turning-point, and works of such outstanding quality or extraordinary force that only Rembrandt could have painted them. This book presents a selection of those works, sixty paintings in which Rembrandt – and only Rembrandt – is revealed both at his most characteristic and at his most various, through the different stages of his career.

A succession of scholars have contributed in the twentieth century to the gradual diminution of the world's Rembrandts, or to put it more positively to the isolation of Rembrandt's particular genius, in contrast to the imitations of his many pupils and followers. Currently Rembrandt's entire oeuvre is being examined by a number of eminent Dutch art historians working together in the 'Rembrandt Research Project', initiated in 1968. Although its published findings cover only the first part of Rembrandt's career, there has obviously already been a thorough investigation and discussion of his later works as well, which this book, published for the Rijksmuseum and written by a member of the Rijksmuseum's staff, now reflects. Out have gone some old favourites, such as the *Man in a golden helmet* in Berlin or the *Polish Rider* in the Frick Collection in New York, rejected or at least questioned. But there is no doubt whatsoever about the status of the works Rembrandt included here. They constitute the touchstones by which other paintings stand to be judged.

To the nineteenth century, Rembrandt was the 'artist of genius', the man who did not give a damn for the conventions of society, and who under the spur of inspiration wanted to do only one thing – paint. The first half of this century produced the image of Rembrandt the 'misunderstood' artist, the man who after the completion of the *Night Watch* could expect nothing from his public except incomprehension, but who continued indomitably on the road he thought the right one. In the 1950s the image evolved of Rembrandt the painter of people, a man with the exceptional gift of penetrating deep into the psychology of his sitters; also Rembrandt the profoundly religious painter, who knew how to tell biblical stories with infinite understanding.

Today we try above all to build up a realistic picture of Rembrandt, without glorification, without superlatives, as a man of both good and bad qualities. To achieve this what is known of Rembrandt must be tested against the attitudes, ideas and customs of his own time, to see to what degree he was exceptional by the standards of his period, if at all. By reconstructing the milieu in which Rembrandt lived, discovering who he associated with, who lent him money, who gave him commissions, we can discern more clearly what influences he was subjected to, where he obtained his subjects, what he knew of the art of his predecessors, and what he did with that knowledge.

Modern research, including chemical analysis of the paint and X-ray, infra-red and other kinds of photography, can reveal much more about Rembrandt's habits and technique in building up a painting than was known before. However, detailed examination of a painting with the naked eye is also of the greatest importance, to establish the way in which Rembrandt applied his paint, the layers with which he built up a painting, how he suggested shadow, how he managed to paint light. Only all these factors together make it possible to determine whether a painting is a real Rembrandt, or the work of a follower, a pupil, an assistant, or perhaps even a copyist or a forger. In spite of the continual research, in spite of the constantly increasing amount of factual material, both technical and historical, Rembrandt himself will always remain to some extent hidden. Or, to put it rather better, every generation will continue to create its own image of Rembrandt from the existing data, evolving its own emotional response to the works of art he made.

# The Paintings

# A scene from history    1626

No. 1

Panel, 90.1 × 121.3 cm
*Leiden, Stedelijk Museum De Lakenhal*
(on loan from the *Rijksdienst Beeldende Kunst*)

A richly dressed prince, sceptre in hand, is standing on a dais, surrounded by his
staff. The two men kneeling in front of him are clearly asking for forgiveness.
Behind them stands a man with arm upraised as if taking an oath. In the
foreground lie arms and armour, and in the background a town can be seen
which could be Rome or some other city of antiquity. What is the subject?

Suggestions advanced include the clemency of the Roman emperor Titus,
famous for his wise government, letting two patricians who had plotted a
conspiracy against him go free. Or again the story of Palamedes, son of
the admiral of the Greeks, kneeling before King Agamemnon of Mycenae.
Palamedes was accused of treason, Agamemnon condemned him and sentenced
him to be stoned. But the supposed proofs against him had been contrived by
Odysseus, who had wanted to avenge himself because Palamedes had caused
him to be drawn against his wishes into the war with Troy. The story was an
'example' of condemnation on false evidence.

The poet Vondel had used the same story in 1625 for his play *Palamedes oft
vermoorde onnooselheyd* (Palamedes or Murdered Innocence). It was clear to
contemporaries that the play was not really about ancient Greece, but about
an event of the time, the condemnation of the Grand Pensionary Johan van
Oldenbarnevelt, who was beheaded in 1619 on the orders of the Stadtholder
Maurice. The evidence on which this judgement was based was, in the opinion
of many, at best doubtful.

Unfortunately Rembrandt's illustration of the subject is not clear enough to
know for certain what he intended. If it is indeed about Palamedes, why does it
show three men? And if it is the judgment of Emperor Titus, then two men
should have been represented.

The painting is one of the first Rembrandt made in his new capacity as his
own master. We may deduce that ever since boyhood he had wanted to become a
history painter, an illustrator of stories mythological, religious and historical: that
is probably why in 1624 he went to Amsterdam to study under Pieter Lastman.
Lastman was also a history painter. Shortly after 1600 he had worked for a few
years in Italy, and had there become acquainted, not only with the works of the
Italians, but also with the paintings of the German Elsheimer who was then
living in Rome. His line in colourful paintings of a fairly small size, crowded
with figures, was taken up by Lastman, together with the carefully contrived
landscapes in which Elsheimer mostly placed his scenes. The first paintings
which Rembrandt, having returned to Leiden, made as a painter working on his
own account still look very like Lastman's – colourful, crowded, with plenty of
action. On one point Rembrandt attempted to improve on his master. While
Lastman's paintings are lit evenly throughout, Rembrandt used light and shade
to make the picture more dramatic. In this painting the light comes from behind
the prince, and shines straight on to the group in front of him. The play of light
and shadow in the folds of the oriental-looking carpet draped over the steps is an
ingenious way of filling the space between the prince and the supplicants. The
figures themselves are still rather stiff and clumsy, like actors in a badly staged
play. Rembrandt had the ambition to paint a big historical scene, but not yet the
ability to bring one off.

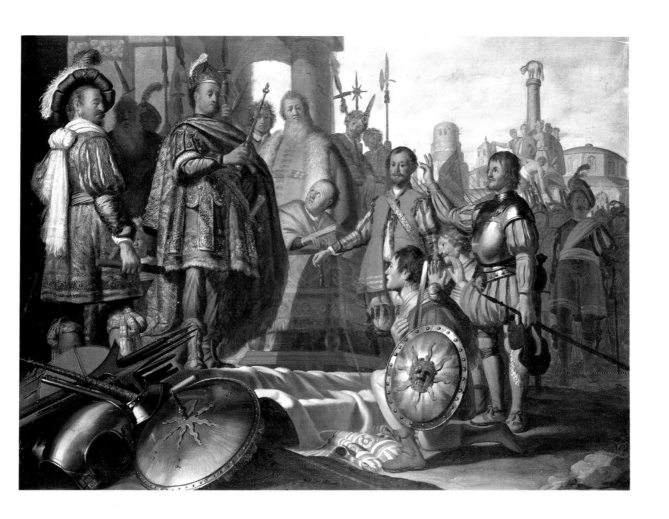

# St Philip baptizing the
# Queen of Ethiopia's Eunuch 1626

No. 2

Panel, 63.5 × 48 cm
*Utrecht, Rijksmuseum Het Catharijneconvent*

The Apostle Philip is seen baptizing the Queen of Ethiopia's chief treasurer, who was a eunuch. The eunuch was on his way home after visiting the Temple in Jerusalem, and was reading in his chariot the prophecies of Isaiah in which the coming of the Messiah was foretold. Had he perhaps heard in Jerusalem of Jesus, who had said that he was the Messiah, who was crucified, but had risen from the dead, and whose followers were constantly increasing in numbers? He did not, however, understand Isaiah's writings. Then Philip, guided to the road between Jerusalem and Gaza by an angel, appeared as if he had been summoned. The eunuch invited him into his chariot to explain the scriptures to him, and Philip told the eunuch that Jesus was the man Isaiah had prophesied would sacrifice his life for humanity. He made such a profound impression that the eunuch asked Philip, when they reached some water, to baptize him.

The Baptism of the Eunuch was a popular subject in the Netherlands. Possibly it provided an incentive to the Dutch to do missionary work among the foreign peoples with whom they came into contact as a result of their trade with East and West.

For his picture Rembrandt chose a vertical format, which did not make its composition any easier. He was forced more or less to pile the figures up in the painting, placing them in a half circle one above the other, the eunuch, Philip, a servant with the eunuch's turban, a servant with the Bible, the chariot and horses, and three other servants. In order to give his painting depth, he made the figures not only smaller as they receded, but also vaguer. In the bottom left corner, to cut off the half-circle, Rembrandt painted a dog drinking – an ingenious way of indicating that water was to be found there. He left both right-hand corners free; at the bottom he signed his monogram RH (Rembrandt Harmenszoon) with the date.

Here, too, it is plain to see how Rembrandt has used light to bring out what is most important in the painting. The light falls on the Bible, which, after all, was the immediate cause of what happened, and on Philip's face. It also shines upon Philip's hand, raised in the gesture of baptism, which the observer sees outlined clearly against his pale-red cloak. Most of the light, however, falls on the eunuch, the central figure of the painting, whom Rembrandt has moreover clothed in a striking pale-yellow fur coat. For Rembrandt's patrons and customers, who would generally have been Protestant, paintings of religious subjects had no function as objects of worship or veneration, but only as examples of good conduct. A painting of the baptism of the converted eunuch satisfied this requirement admirably.

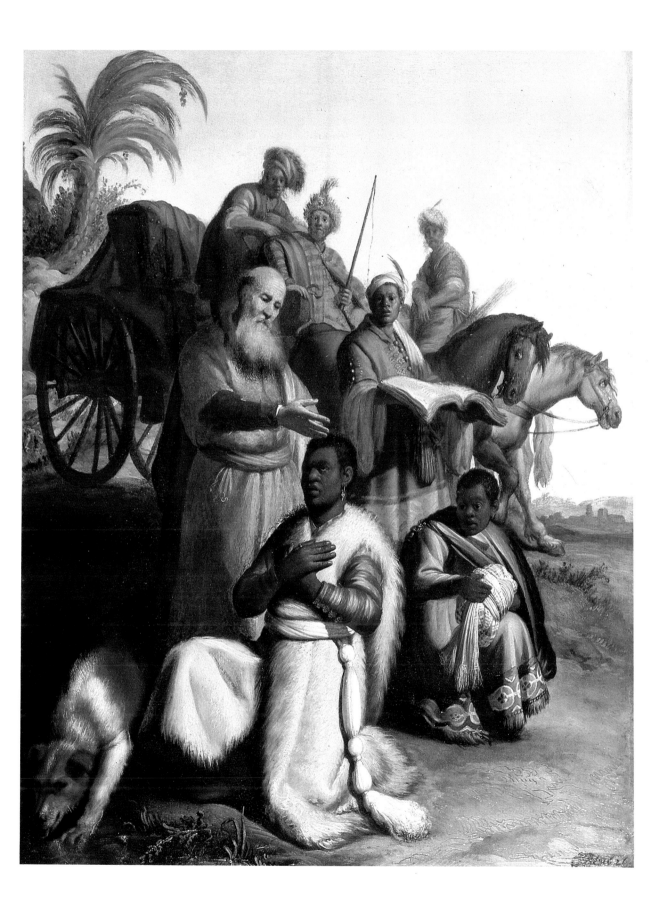

# A music party    1626

No. 3

Panel, 63.5 × 47.6 cm
*Amsterdam, Rijksmuseum*

Four figures in an interior, a young woman and an old one, a young man and a
middle-aged one. Three are making music: the young woman is singing (she has
a score on her lap), the young man is playing the harp, and the other man the
*viola da gamba*. More musical instruments are lying about the room, a viol and a
lute, and the books in the foreground appear, where they are open, to be books
of scores. Clearly, a musical party. But it is certainly not an everyday group of
people playing music. The scene is too emphatically posed, and the figures are
dressed too fancifully. On the wall is a picture of the story of Lot, who, on God's
advice, fled with his wife and daughters from the depravity of Sodom: is it a
warning which bears some relation to this music party?

In seventeenth-century pictures music is often a reference to love, not only
because of the harmony which is so important in both love and music, but also
because of the seduction that can be worked by music. This seductive quality of
music may well be illustrated here. The young woman in her luxurious dress
holds men enthralled, whether they be young or old. The old woman is her
companion: in many seventeenth-century paintings such women appear as
procuresses, arranging the financial transactions between the temptress and
her customers.

Rembrandt was developing fast in 1626. He shows here that he had already
to a large extent learnt to achieve a balanced composition. Light played an
increasingly important role in this. The bright light shining forward on to the
picture from somewhere on the left falls full on the woman singing in the centre,
and on the books at her feet, but also throws deep shadows, the shadow of the
chest in the foreground that is seen against the light, the shadow of the young
woman's head on the old woman behind her, the shadow of the young man's
head on the curtain draped in the right upper corner. This complicated play of
light and shade brings the painting alive, and gives depth to the picture.

The preference for hard colours – the green of the table cloth, the bright red
shoes – derives from Lastman, whose 'legacy' is still felt.

Many Leiden painters of the period were specialists in the painting of *vanitas*
pictures, still lifes illustrating the transitory nature of life by showing old books,
musical instruments, a single rose, an hourglass, a candle, etc, sometimes even a
skull. That this genre had its influence on Rembrandt can be seen from the still
life of books in the foreground of the painting, with strikingly painted folios in
parchment bindings that clearly show years of use.

The year 1626 was an important one for Rembrandt: he acquired his own
studio in Leiden, in partnership with Jan Lievens, another ex-pupil of
Lastman's. Obviously things were going well for him at the age of twenty.

# Anna accused by Tobit of stealing a kid 1626

No. 4

Panel, 40.1 × 29.9 cm
*Amsterdam, Rijksmuseum*

Tobit was a dedicated servant of God, even in defiance of the prohibitions of the rulers of Israel. Even when he became blind, when he could no longer carry out his duties, and henceforth was confined to his house, he remained faithful to the Lord. His wife Anna had to go out to work and earned a meagre wage spinning. One day Anna came home with a kid, which she had been given by one of her employers. Tobit heard the kid bleating, and began to exclaim against Anna: the kid could have been stolen. But then Anna too became angry: Tobit might be a faithful servant of God, but he was too quick to suspect others of theft. Then Tobit was horrified at his lack of faith, and he prayed to the Lord to forgive his unworthy behaviour; he was so sinful, it would be better if he were dead. Anna watched him in bewilderment.

Though the Book of Tobit had been declared apocryphal since the Synod of Dordrecht in 1619, the story of Tobit had lost none of its popularity. People liked the moral import of the story of the man who, in spite of great adversity, remained faithful to God, and in the end was rewarded for it. Rembrandt illustrated scenes from the story of Tobit several times (see also no. 20).

Rembrandt had a model when he made this painting, an engraving by Jan van de Velde after a drawing by Willem Buytewech. This shows the same kind of room, with more or less the same objects in it and the figures of Tobit and Anna also similar. However, while in Buytewech's drawing Anna is shown soundly telling her husband off, Rembrandt chooses another moment, one with much more tension, Tobit's remorseful prayer.

Rembrandt at the beginning of his career was gradually discovering that it is not only the ability to represent in paint that makes a good artist, but also the choice of what aspect of the subject to represent. Now and later in his biblical pictures he often chose moments of contact with the divine, showing people reacting to God's intervention in their lives. He would later discard all those objects with which he has here filled his space, the onions, the bird cage, the basket – painted with a great eye for detail – the bottles and dishes on the dresser. Now he still thought it important to point out that Anna earned her living by spinning by painting in a spindle. Later he decided that such details distracted attention, and concentrated on the protagonists and their reactions.

This painting must have been painted towards the end of the year, since it marks an enormous step forward compared with other paintings of the same year, 1626. Rembrandt seems suddenly to have found his own style. His figures are truer to life, more dramatic, his colours more restrained, more harmonious. The rendering of hands and faces now has that expressive precision that makes Rembrandt's later paintings so fascinating.

The way in which Rembrandt placed his monogram and the date at the bottom left shows how he tried to give even the smallest detail a logical place in the whole composition: the letters and figures are painted so that they appear to have been carved in the floorboards.

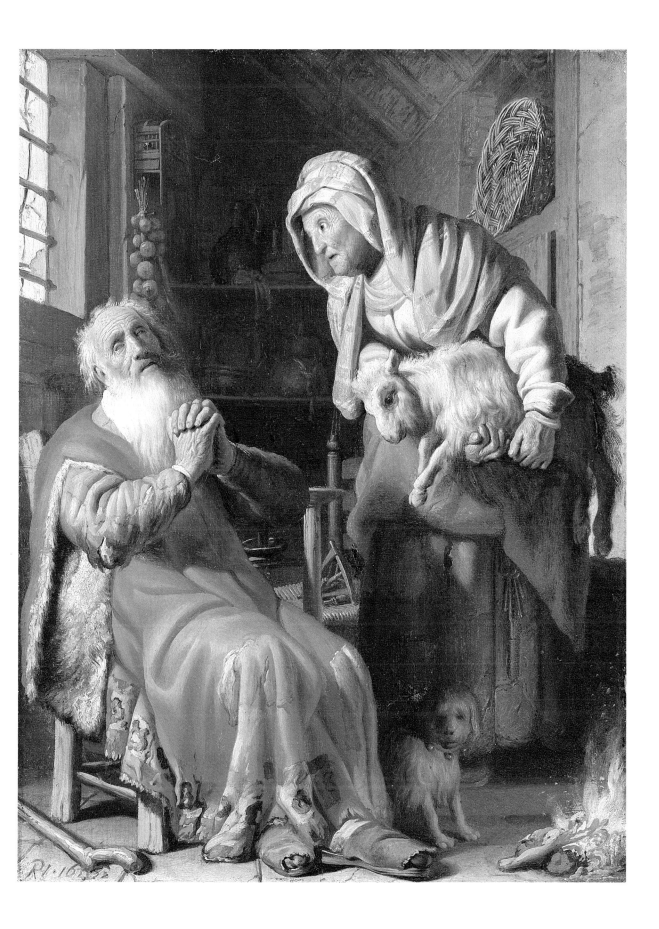

# Self-portrait   *c*1628

Panel, 22.5 × 18.6 cm
*Amsterdam, Rijksmuseum*

This is not really a self-portrait in the usual sense of the word, but a study of the artist's face probably made mainly to register the unusual lighting – eyes and mouth in shadow, with the light from the left on his curly sandy hair, on the tip of his nose, his right ear, his right cheek, neck and shoulder. Although self-portraits of this kind, or rather observations of one's own face, are unusual in seventeenth-century painting, for Rembrandt it was obviously a useful exercise, enabling him to study emotion, whether of surprise, pleasure or grief, under various different lighting conditions, and he also made drawings and etchings of his own facial expression during this period.

People often claim to recognize that same face in Rembrandt's history pictures among the bystanders or as one of the protagonists. Should one suppose that Rembrandt wanted to portray himself in these cases, or does one see just the face of a young man, arbitrarily chosen, resembling more or less accidentally the painter himself?

In this self-portrait, as in others, Rembrandt painted himself as he saw himself in a mirror: his nose is rather broader than in reality, because it was the nearest feature to the mirror. He has rendered his curly hair in a distinctive way, by scraping away some of the top layer of paint, so as to let the reddish-brown coloured priming show through.

In these years Rembrandt began to sign his paintings regularly with the monogram RHL, an abbreviation of Rembrandt Harmenszoon Leydensis (Latin: 'from Leiden'). Was it a sign that the young man wanted to spread his wings outside Amsterdam as well? Very rarely Rembrandt signed his paintings with his surname Van Rijn, which his father had derived from the mill called De Rijn by the Leiden city-wall beside the bank of the Rhine. In Amsterdam, too, he remained faithful to the letters RHL, until half-way through the 1630s he began to make use of the self-assured 'Rembrandt', spelled in full.

Self-portraits, though not unknown in seventeenth-century Dutch painting, were generally an opportunity for painters to present themselves in smart poses as respectable members of society. The self-portraits made by Rembrandt, examining his own external appearance in unposed renderings without any embellishment, are unique. Thanks to the many portraits Rembrandt produced of himself throughout his life, in paintings, drawings and prints, he has become, at least in outward appearance, one of the most familiar characters of seventeenth-century history.

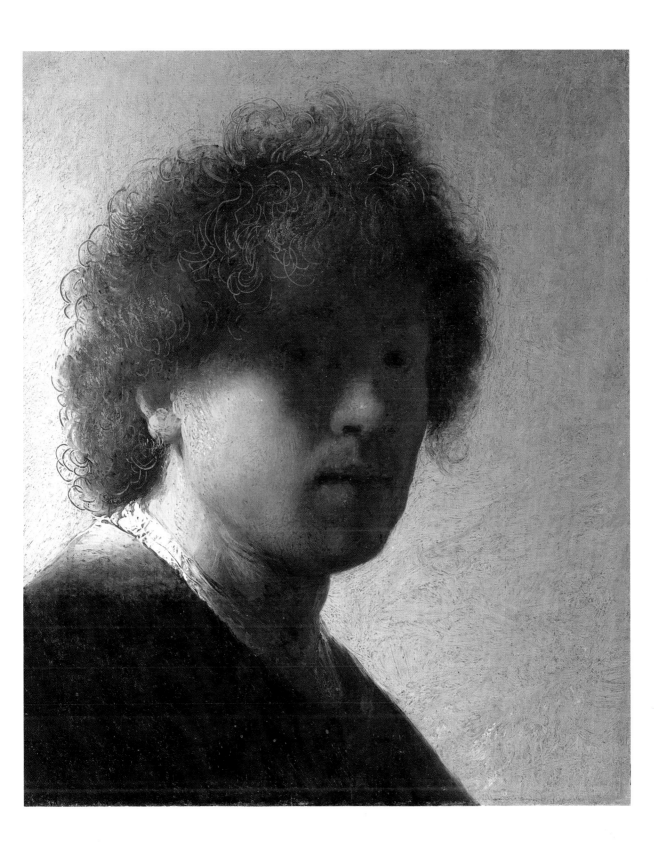

# The young artist in his studio  *c*1629

No. 6

Panel, 25.1 × 31.9 cm
*Boston, Museum of Fine Arts*

A simple room, wooden-floored, with whitewashed walls, crumbling a bit here and there. By the table stands a young painter. He is dressed finely in a long fur-trimmed coat over his everyday clothes. The sleeve of the coat is unbuttoned, showing his right arm extended with a brush ready in his hand. In his left hand he holds a palette with yet more brushes and with his little finger he grips his maulstick, a support for the painter's hand while he is painting.

Behind the painter is a large stone for grinding paint, on a wooden block with legs; on the table behind him are a bottle and a jug. Just in front of the door stands his easel, its back to the observer. On the easel is a large panel, with a protective edge at top and bottom. The observer remains in ignorance about what there is to see on the panel. And to emphasize the mystery of it, Rembrandt makes the light shine full on the work in progress. The young painter in his long coat remains rather in the shadow.

What is the object of this small painting? Pictures of painters in their studio were not unusual in the seventeenth century. But almost always the painter would be at work, sitting in front of his easel, painting industriously, and the observer is favoured with a sight of the work. In most cases, too, the studio is packed with all those things needed by painters in their *métier*, pattern books, drawings, a manikin, things waiting to be painted. This studio is almost empty, and the young man's clothes do not suggest that he is really actively at work: the long sleeve of his coat would be an effective obstacle to painting; his pose, too, is unusual. To look at one's work from a distance may be normal for painters nowadays, but in the seventeenth century the habit was unknown. Painters painted their pictures sitting close up to their canvas or panel. They even judged the effect from a distance from this position.

A possible explanation is that Rembrandt wanted to illustrate not the actual painting, but the excogitation of an idea, the genesis of the painting. The diminutive painter in the long coat is creating in his mind the painting he is about to produce. The painting implements in his hand are not meant to work with, but are attributes indicating that he is a painter and not an occasional visitor to the studio.

For painters like Rembrandt, designing a painting in the mind was an extremely important stage of their preparatory work. Rembrandt in particular rarely made preliminary studies on paper for his paintings: the necessary preparations took place in his head.

In 1628 he started to take on pupils: his first was Gerard Dou, then fifteen years old, who was to live in Rembrandt's house until Rembrandt left for Amsterdam in 1631, and to develop into an important painter in Leiden. Rembrandt's early fine, precise manner of painting on small panels was adopted by Dou and used by him throughout his life with great success.

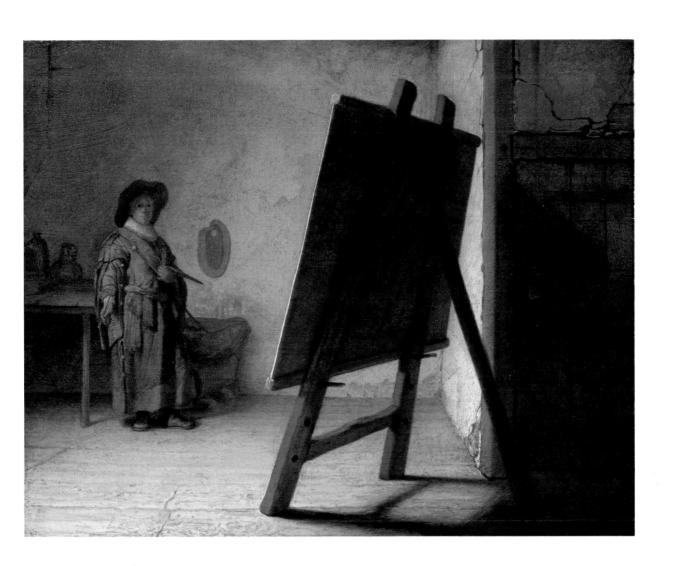

# Jeremiah lamenting the destruction of Jerusalem     1630

No. 7

Panel, 58.3 × 46.6 cm
*Amsterdam, Rijksmuseum*

Jeremiah was summoned to be a prophet in the thirteenth year of the reign of King Josiah, in 627 BC. In a vision he was given the task of warning the people of Israel of the terrible consequences if they would not listen to the word of God; no-one paid heed. In 586 his prophecy that the unconquerable city of Jerusalem would be destroyed was proved right: Nebuchadnezzar II, King of Babylon, destroyed the city, and his army burnt the royal palace, the Temple of Solomon, and the dwellings of its prominent citizens. All the treasures of the Temple – vessels, bowls, candlesticks of gold and silver – were carried off as spoils of war. Jeremiah was allowed to stay in Israel, together with the poor whom the army left behind; the remainder were marched off to enslavement in Babylon.

The aged Jeremiah sits in a ruin resembling a grotto, supporting his head on his hand, in an unmistakable attitude of sadness and melancholy. His arm rests on a Bible, in front of him lies some gold plate; had he been able to rescue something from the Temple? In the distance is Jerusalem, sacked and in flames; Nebuchadnezzar's army is marching into the city. Above the city hovers a figure with a blazing torch, perhaps a symbol of the wrath of God.

In the 1630s Rembrandt made a large number of drawings of old men, from which it is apparent that he had a keen eye for all the distinctive signs of age. In his figure of Jeremiah, which had its origin in these drawings, Rembrandt has rendered with meticulous detail the high balding forehead with its deep wrinkles, the sad old eyes, the fine white hair, the old hand with its loose, wrinkled skin, the old foot, sticking out beneath his clothes. It was obviously a theme which at this period fascinated Rembrandt, because several more paintings are known from the same year featuring old men – St Paul in his old age, for example, or St Peter. It was once thought that Rembrandt's father had sat as a model for these paintings and drawings, but the fact that Harmen died in 1630, and that there are also drawings and paintings of this kind dating from after 1630, makes the supposition improbable.

Rembrandt gave his city of Jerusalem an appearance probably based on prints with which he was familiar. In the prints of Jerusalem in circulation in the seventeenth century there is always a round building that Rembrandt and many of his contemporaries took for the Temple of Solomon. In reality, however, it was the Dome of the Rock, which the Arabs had built in 691 on its site.

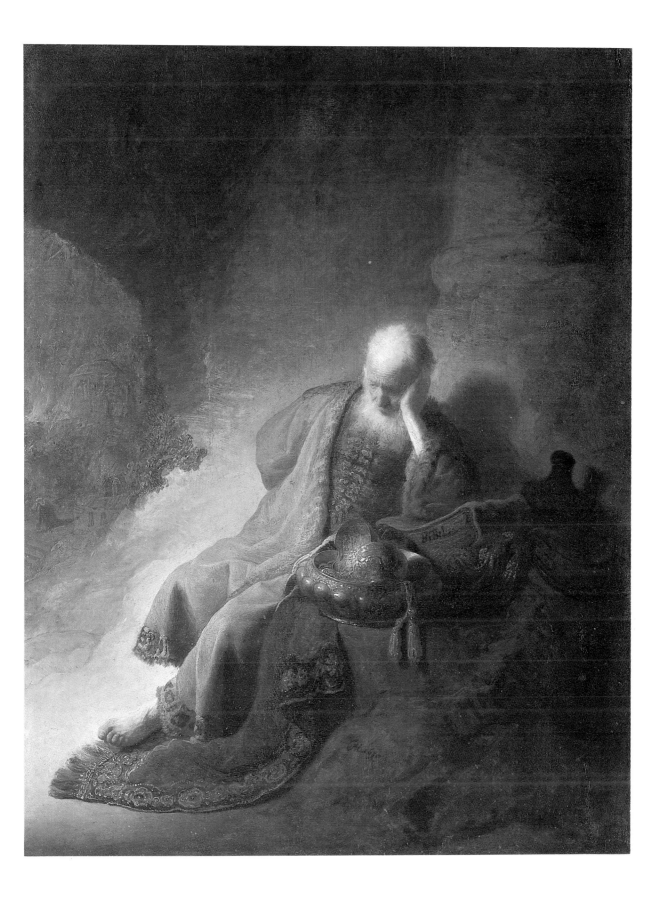

# The Prophetess Anna    1631

No. 8

Panel, 59.8 × 47.7 cm
*Amsterdam, Rijksmuseum*

When Joseph and Mary took their child Jesus to the temple in Jerusalem, as prescribed by the Law, to present him to the Lord and to sacrifice two doves, there was also in the temple one Anna, a prophetess, a widow who spent her days and nights praying there, who recognized in Jesus the Messiah of whom the Prophets had spoken. Eighty-four years old according to the Bible, Anna is a very old woman in Rembrandt's painting. Since she knew the scriptures well, Rembrandt placed on her lap a Bible in which Hebrew script can still be faintly recognised. He took every trouble to clothe her in what seemed to him an oriental garb, with a rich deep red cloak and a fanciful covering on her head. The light comes from behind her, touching her headdress with gold, putting silvery edges on the velvet of her cloak, and shining full upon the Bible and on her old wrinkled hand which she has laid on one of its pages. The hand is extremely finely painted, with its corrugated skin, raised veins and old nails. Anna's face remains in shadow, but even so Rembrandt has managed to express the age of the woman in it. The red of her cloak was undoubtedly even more glowing originally, but has darkened with age.

It has been supposed that Rembrandt's mother Cornelia (Neeltje) Willemsdr van Zuydtbroeck sat as model for this painting of Anna. She married Harmen van Rijn in 1589 and was then, like her husband, just 21. In 1631 she was therefore well over 60, but perhaps not old enough yet to be a model for this ancient wrinkled Anna. Since Neeltje van Zuydtbroeck could, like most women at that time, neither read nor write, when in 1635 she had to give her permission for Rembrandt's marriage, she signed with a cross. Rembrandt was the ninth of her ten children, of whom three died young. Neeltje died in 1640.

In the year Rembrandt made this painting he was to move permanently to Amsterdam. As far as is known, he was never to return to Leiden. In Amsterdam Rembrandt was to abandon the meticulous technique of painting on small panels in favour of a freer style employed on larger canvasses. But in spite of this change in style and size he remained faithful to the subdued palette which he had gradually made his own, and retained, too, his fascination with light throughout his career.

22

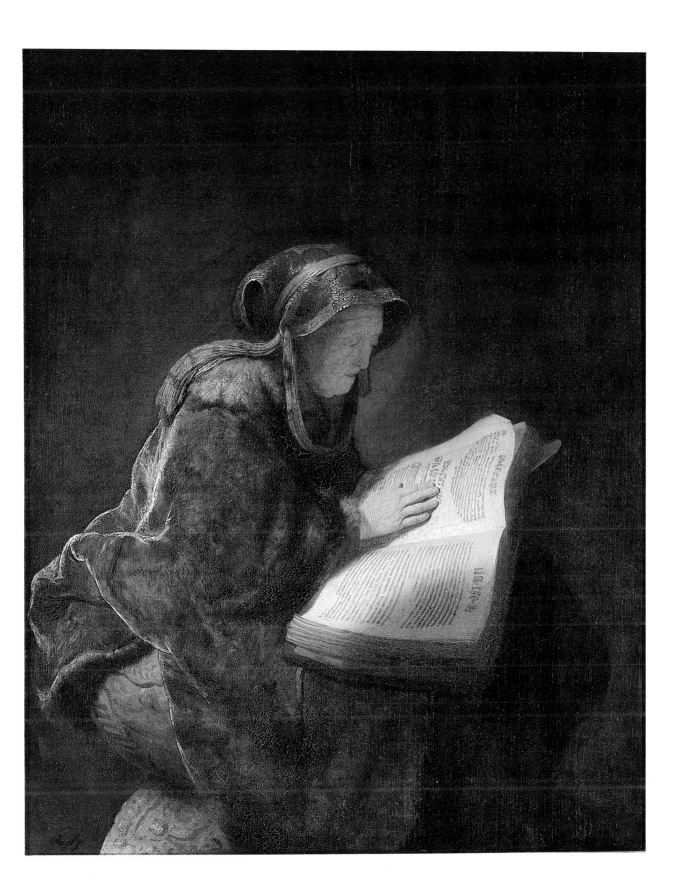

# Nicolaes Ruts    1631

No. 9

Panel, 116.8 × 87.3 cm
*New York, The Frick Collection*

Nicolaes Ruts (1573–1638) was an Amsterdam merchant, whom trade with Russia had rendered prosperous. He was of Flemish origin, but was born in 1573 in Cologne, where his parents had fled when it became impossible for Baptists to live in Catholic Flanders. At first Protestants were made welcome in Cologne and its countryside as well as in the northern Netherlands, but after Cologne, too, had come under Spanish government, in 1614 Ruts decided to establish himself in Amsterdam. He would undoubtedly have found many compatriots there.

The Russian trade included furs among other products, and this could be the reason why Ruts had himself portrayed by Rembrandt in a fur-lined coat and fur hat. There is documentary evidence that the portrait hung for some time in the shop kept by Ruts's daughter Susanna on the Oudezijds Voorburgwal. Susanna, too, had connections with Russia, since the cloth from her shop was exported there, and perhaps Ruts's portrait in the shop served as some kind of evidence of reliability.

In the picture Ruts is 58 years old; he was to die seven years later. His financial position had by then changed for the worse: he had had to come to an arrangement with his creditors, who had to be content with one third, since it was impossible to pay off all his debts.

Rembrandt took great pains to make the portrait come alive, for instance by the way the sitter is posed, turned slightly away from the observer and then turning back towards him to hand him a letter. The text on the letter is illegible; only the date 1631 can still be made out. It is not known whether, when the painting was new, there was ever any legible text.

Portraits were paid for by a fixed tariff. The most expensive were full-length, a type for which there was only small demand among private citizens in the Netherlands. The cheapest were portraits showing only head and shoulders. Portraits like that of Ruts, in which the figure was represented three-quarter length, on a large panel, belonged to the more expensive category.

When he moved to Amsterdam in 1631, Rembrandt was taking no risks: he had previously, for 1000 florins, bought himself into an art dealership run by Hendrick van Uylenburgh. Apart from dealing in art Van Uylenburgh had painters who worked for him, and for whom he organized commissions. Rembrandt went to live with Van Uylenburgh in Amsterdam, in his house in Sint Anthoniebreestraat, where he was given a studio. In these first years in Amsterdam, Rembrandt, probably through the good offices of Van Uylenburgh, worked mainly as a portrait painter. In the prosperous self-confident city there was great demand for this kind of painting, and Rembrandt knew how to execute portraits which were both modest and impressive, a talent which would very much have pleased his generally Protestant patrons.

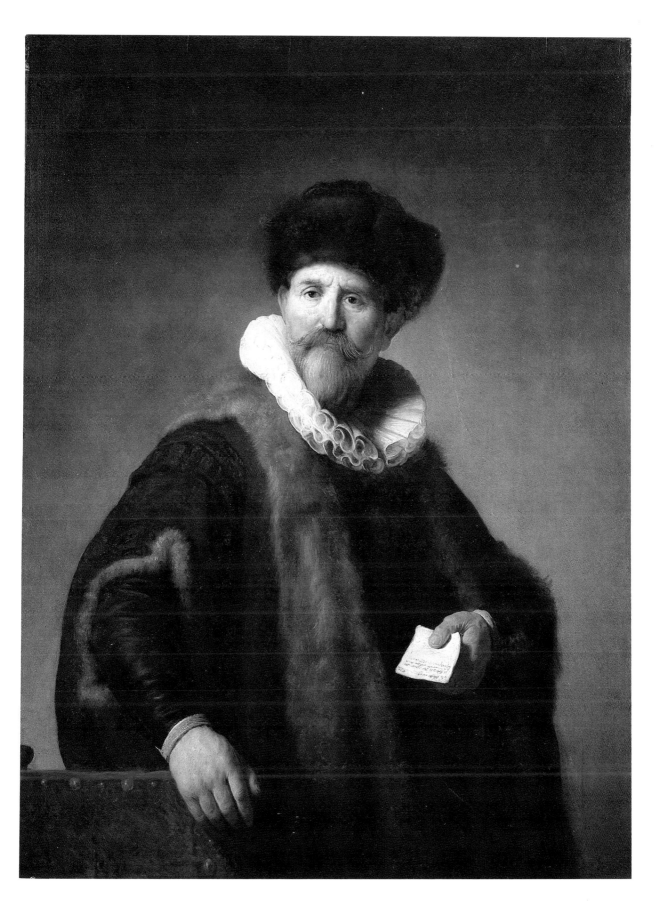

# The anatomy lesson
# of Dr Nicolaes Tulp    1632

No. 10

Canvas, 169.5 × 216.5 cm
*The Hague, Mauritshuis*

Practical lessons in anatomy were rare events: dissections of a cadaver were allowed only once a year, using the body of a victim of the death penalty. (At other times surgeons had to acquire their knowledge from books, from preserved specimens and from actual practice.) Precise notes were made of every anatomy lesson in the *Anatomye Boeck* of the Surgeons Guild, usually with a mention of the name of the condemned man and his crime.

A chair of anatomy was created in Amsterdam for the first time in 1628, and the first professor there, the *praelector anatomiae*, was Dr Nicolaes Tulp. On 31 January and 2 February 1634 Dr Tulp gave an open lecture to a select group of surgeons.

It must have been a considerable honour for Rembrandt to be invited to record this important event. It is unlikely that he actually attended the lecture, and his representation is not entirely realistic, since every lesson in anatomy began by cutting open the abdomen and removing the perishable intestines. As an anatomy lesson lasted three days, this was very necessary. The corpse was the body of a Leiden citizen, Adriaen 't Kint, who was executed on 31 January for the theft of a cloak.

In the painting Professor Tulp is demonstrating the physiology of the arm, showing the muscles that move the fingers. Rembrandt had probably copied this arm from a drawing or from a preserved specimen, although it may seem that he had studied a real arm cut open for the purpose, since the rendering is striking in all its detail.

Only those surgeons who were prepared to pay for their portraits were in fact represented in the group portrait. It is known who they were, for their names were later listed in the sketchbook held by the man next to Dr Tulp, where previously there was an anatomical drawing. Before he composed his group, Rembrandt would have made separate studies of the different heads. Many artists before him had confronted the problems of arranging portraits in a group painting, and Rembrandt must have learnt both from their successes and from their failures. He tried to bring the group to life by making each person look in a different direction, yet without giving the impression that they were not paying attention. Dr Tulp – as the most important he is the only one wearing a hat – is teaching, making the kind of gestures which orators have made since antiquity.

Rembrandt's painting eventually hung in the Theatrum Anatomicum in the Weighhouse on the Nieuwmarkt. Twenty-four years later a second *Anatomy lesson* by Rembrandt was hung there, that of Dr Deyman, who succeeded Tulp in the chair (no. 42).

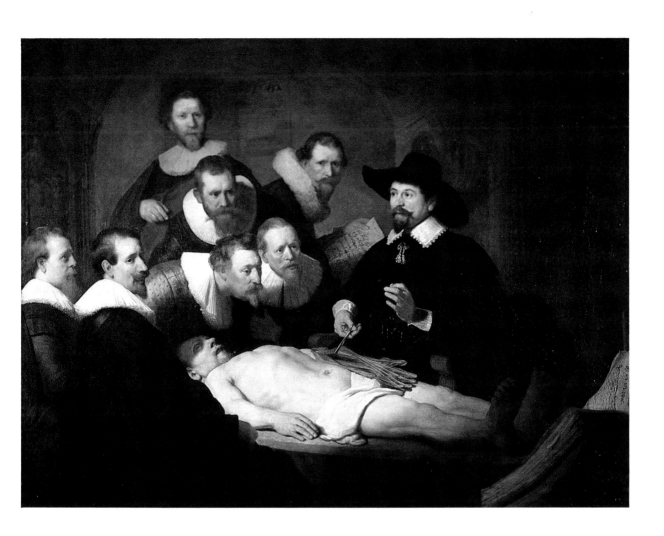

# Saskia 1633

No. 11

Panel, 65 × 48 cm
*Amsterdam, Rijksmuseum*

On 5 June 1633 Rembrandt was betrothed to Hendrick van Uylenburgh's twenty-year-old niece, Saskia, who came from Friesland. Orphaned while still a child, she was raised by her sisters there, but she had probably also lived for some time in Amsterdam with her uncle Hendrick or with other members of her family, and in this way had met Rembrandt. Saskia's father had several times been burgomaster of Leeuwarden, and had even played a role for a time in national politics as a government prosecutor. Saskia, therefore, came from a good family. Unlike many of her female contemporaries, she could read and write. Her dowry amounted to 40,000 florins, but the provisions of a complicated will meant that her heir had to make sure that the amount remained intact.

Saskia is the only one of Rembrandt's family of whom we have a certain likeness. Shortly after their betrothal Rembrandt made a drawing of her – a pretty girl with a round face, adorned with a wide straw hat – under which he wrote: *dit is naer myn huysvrou geconterfeyt do sy 21 jaer was den derden dach als my getroudt waren den 8 Junyus 1633* (this is my wife painted when she was 21 the third day after we were betrothed, on 8th June 1633). The quotation expresses tenderness and pride; it is the most personal witness we have of Rembrandt.

Encouraged by this small portrait drawing, people have claimed to recognise the likeness of Saskia in a great many of Rembrandt's paintings, including this one made in 1633, the year of the betrothal. The woman looks rather older than Saskia in the drawing, however. It is not a true portrait, for the woman is dressed in fanciful costume, and not in normal seventeenth-century clothes. She is looking composedly, perhaps somewhat coolly, at the observer. The painting has at some time suffered considerable damage near the left corner of her mouth, which was later rather clumsily painted over, so that she now has a rather pouting expression, which is probably not what Rembrandt intended. The picture was also originally rectangular; it was turned into an oval later, not entirely felicitously, so that the woman's head seems to fit rather oddly in the picture space.

After 1633 Rembrandt started signing his pictures with his first name only, usually written in a conspicuous place. Was he in this following the example of Italians like Raphael and Titian, who became universally known by their first names alone?

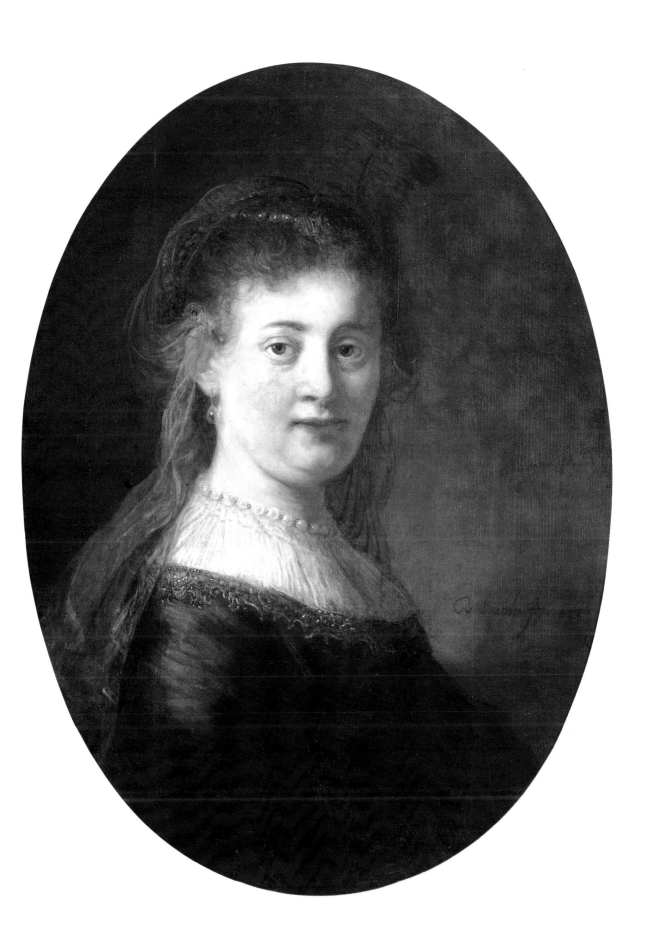

# The Raising of the Cross  *c*1633

Canvas, 96.2 × 72.2 cm
*Munich, Alte Pinakothek*

In 1629 Constantijn Huygens had visited Rembrandt and his partner Jan
Lievens in Leiden. As Secretary to the Council of State, in the service
successively of Stadtholders Frederick Henry, William II and William III,
he had influence also in the arts, in which he was greatly interested: he com-
posed music, played several instruments, and was a talented poet. Huygens
was impressed with Rembrandt and with Lievens. In his autobiography he
prophesied that within a short while these two would surpass the artists he
had previously cited as pre-eminent. About 1633 Huygens got in touch with
Rembrandt again, and on behalf of the Stadtholder Frederick Henry ordered two
paintings from him with scenes from Christ's passion, a *Raising of the Cross* and
a *Deposition*. For the *Raising* Rembrandt chose a strong diagonal composition, a
solution he had perhaps come across in German prints, in which the subject is
often represented in this way. The diagonal is strongly emphasized by the soldier
at the foot of the Cross, dragging the Cross upright with all his strength. The
light on his hands, his silver-coloured sleeve and cuirass follows the line down to
the bottom left of the painting. In the middle of the painting, in full light, is a
man who looks very like Rembrandt himself, as we know him from his self-
portraits. Did he want to suggest, by putting his own likeness so centrally, that
everyone, including himself, bore the guilt of Christ's crucifixion?

The rest of the picture is left largely in darkness. The man with the turban,
mounted on a horse, which is half hidden by the Cross, is the clearest to be seen,
though his role in the composition is not wholly clear. On the left a group of
Jews stand together; the one in front seems to be gesturing to indicate that he
has no power to affect what is happening. Further back on the right preparations
are being made for the crucifixion of the two thieves.

Rembrandt delivered the two paintings in 1633. In the next few years
Frederick Henry himself ordered another three pictures from him, to complete
the series, an *Entombment*, a *Resurrection* and an *Ascension*. The delivery of the
pictures was somewhat delayed. They gave rise to considerable irritation on
both sides, and resulted in a lively correspondence between Rembrandt and
Constantijn Huygens, the Stadtholder's secretary. The letters, seven in all,
are the only documents in Rembrandt's own handwriting in existence.
Unfortunately they are businesslike, and offer no closer insight into Rembrandt's
personality. Rembrandt finally delivered the last two paintings in 1639. They
give the impression of not having been made with his usual care. Possibly
Rembrandt needed money because he was planning the purchase of a large
private house, and he may have dashed off the two commissions from the
Stadtholder in order to get his hands on the promised 1200 guilders.

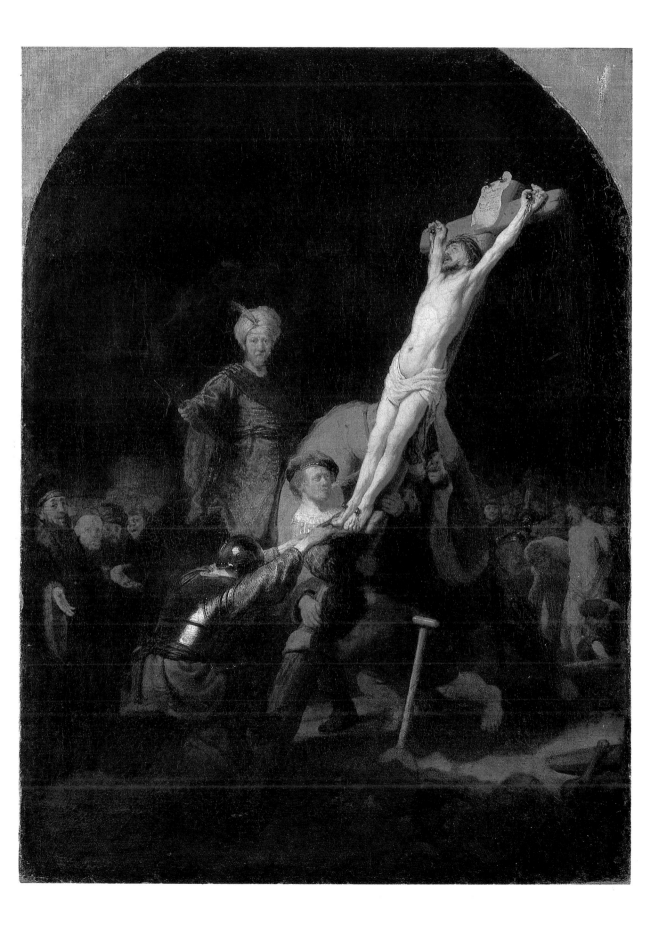

# John Elison    1634

No. 13

Canvas, 173 × 124 cm
*Boston, Museum of Fine Arts*
Pendant of no. 14

John (Johannes) Elison was minister of the Dutch Reformed Church in Norwich, in England; he was born there in about 1581 and died there in 1639. The region near Norwich somewhat resembles the Netherlands, being flat, windy and waterlogged. A considerable number of Dutchmen settled there in the sixteenth and seventeenth centuries, and moreover introduced there the system of water control that had also been so successful in the Netherlands – dykes, canals, sluices and windmills.

There were still close contacts with the Netherlands, and two of Elison's sons established themselves as merchants in Amsterdam. They did well there and when his parents visited Amsterdam in 1634, their son Jan decided to have their portraits painted by the most acclaimed portrait painter of the time, Rembrandt. He wanted not merely their portraits, but the most expensive kind of portrait – full length.

In his portrait John Elison is some 60 years old. He had studied in Leiden from 1598 and in 1604 became minister in his native town, Norwich. He continued his ministry till 1639 when he had to retire for reasons of ill health; he was succeeded by another of his sons, Theophilus.

Elison was portrayed entirely in the accepted style, sitting, as was thought appropriate for clergymen, soberly clothed and surrounded by books, both on the table and in the cupboard behind him. He holds his left hand over his heart, a sign of his true faith. A heavily built man, with a broad, serious face, a thin grey beard, his moustache and side-whiskers not yet grey, a skullcap on his balding head. There is no doubt that this must have been a faithful portrait, and must have kept the memory of his father very much alive for his son Jan.

The portraits of his father and mother stayed with Jan until his death in 1677. Jan had already laid down in his will of 1635 that if he died childless the portraits should go to his brothers and sisters in England. They remained there, with his sister's widower and their descendants, until the middle of the nineteenth century, when they were sold at auction. It was known that they were portraits by Rembrandt, thanks to the signature, but the sitters were a mystery. The name, John Elison, and his profession of minister, were known, but because the portraits were by Rembrandt it was assumed that they were of a minister and his wife in the Netherlands, perhaps the minister of the English community in Amsterdam. A number of ministers with similar names were considered until in 1901 the correct identification was made. In 1934 the will in which Jan Elison left the portraits to his brothers and sisters came to light, and it also revealed the name of the Reverend Elison's wife, Maria Bockenolle.

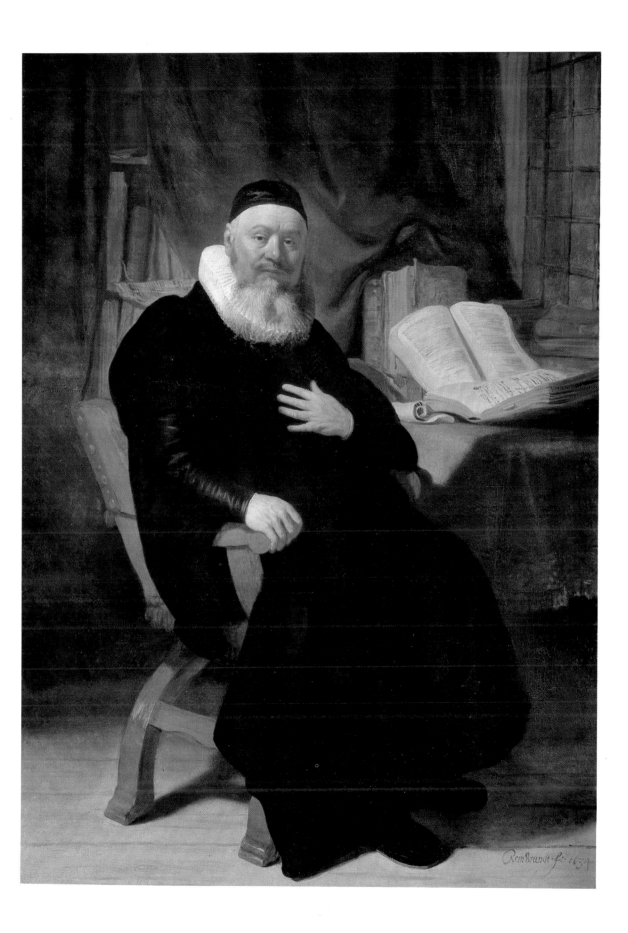

# Maria Bockenolle  1634

Canvas, 176.5 × 124 cm
*Boston, Museum of Fine Arts*
Pendant of no. 13

Thanks to her son Jan's will, in which he left this portrait and that of his father to his brothers and sisters in England, we know that this woman is Maria Bockenolle, wife of the Reverend John Elison. Nothing more is known of her, not even where she came from. In the portrait she seems to be some 60 years old, the same age as her husband. She had had at least five children, four sons and a daughter. The eldest son, Theophilus, succeeded his father in 1639 as a minister in Norwich, the other sons went into trade, two in Amsterdam and one in London; that left the daughter, Anna, whose widower in 1677 inherited the portraits of the couple from Jan Elison in Amsterdam.

Maria Bockenolle is dressed as befits the wife of a minister of the Reformed Church, in sober black, with no adornments to her dress. Some lace is revealed on the cuffs, and on the cap that is just visible under the hat, but even that is discreet. The Reformed Church had strict rules about dress: excessive finery, such as too much lace, was thought unfitting. Collars should be small, and the black clothes unadorned. The wide black hat would have been an unusual accompaniment in the Netherlands: it is clearly an item of English fashion.

In the composition of these portraits Rembrandt was apparently influenced by the portraits being made by his contemporaries in Flanders: this is suggested not only by the pose of both portraits, but by the way in which the background draperies are shown, an enhancement not yet common in the northern Netherlands.

The fact that on religious grounds many of their patrons wore mostly black did not make the task of seventeenth-century Dutch portrait painters any easier: the light falling on the folds, and the shadows in the folds, had to be painted with extreme care, with a rich variation of all sorts of shades, in order to prevent the clothing looking like a plain dark expanse. Especially the little black-on-black decorations, such as those appearing here on the bodice and the sleeves, demanded all their care.

During his first years in Amsterdam Rembrandt had his time fully taken up with portrait painting: about ten are known from the year 1634 alone. However, full-length portraits, such as these of Maria Bockenolle and John Elison, were exceptional. The cost of such a portrait would have made many patrons hold back. But Elison's son Jan was a successful merchant who in 1634 lived in a fine house on the Nieuwezijds Voorburgwal, and by his death in 1677 owned, in property alone, nearly 70,000 guilders.

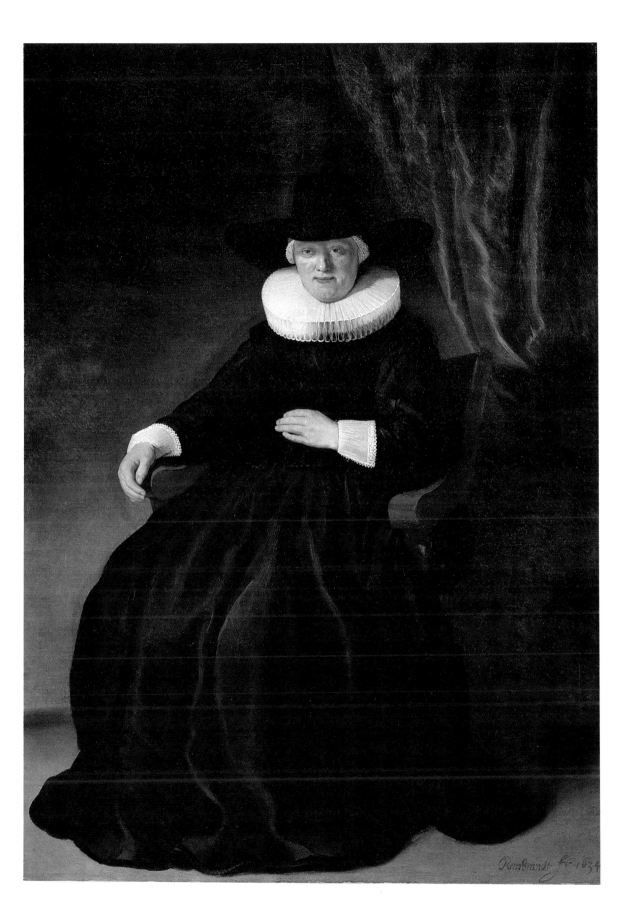

# The Prodigal Son in a tavern   *c*1635–36

**No. 15**

Canvas, 161 × 131 cm
*Dresden, Gemäldegalerie*

A laughing man dressed as an officer, a sword at his side, a plumed hat over his medium-length hair, turns towards the observer and raises his glass of beer as if in a toast. On his lap is an elegant, richly dressed woman, who looks back archly. Life is good, it seems. On their left, part of a peacock pie, on expensive dish that would be consumed only at a banquet, can be seen on the table.

For a long time it was thought that Rembrandt had portrayed himself together with his recently married wife Saskia in this picture, to celebrate the prosperous young couple's happiness. But on closer inspection the picture seems rather too frivolous for a representation of Rembrandt's own domestic bliss.

There are drawings by Rembrandt of a similar subject, a jovial-looking man with a woman on his lap. But from the setting of the couple in the drawings it is plain that they are pictures of the Prodigal Son, who is wasting his share of his father's inheritance in a brothel. In the parable told by Christ in the Bible, the Prodigal Son, having coaxed his inheritance out of his father, went out into the wide world, running though his money in loose living. But the money soon ran out, the son had to earn his living herding swine, and from hunger he ate the swine's husks. At last he decided to go back to his father who received his Prodigal Son, despite everything, with open arms.

The painting was probably a warning against the style of life chosen by the young man in the picture. Many seventeenth-century paintings have a moral meaning like this, which can only be comprehended by an effort of recon-struction; the interpretation was often much easier to grasp in those days than it is for us now.

Originally the painting extended more to the left, and there was then more to be seen of the still life that now seems so oddly cut off by the edge of the picture. Perhaps originally also there was shown more of the setting in which the scene took place.

Rembrandt's arrangement is highly contrived, two figures sitting with their backs to the observer, both of whom have to turn round to look at him. It is certainly one way of making the observer more involved with the painting.

At this time, when he was mainly engaged in making portraits of black-clad Amsterdammers, Rembrandt must have obtained great pleasure from painting such a cheerful, colourful subject. How carefully he painted the intricacies of the woman's dress and of the man's sleeve, interwoven with gold thread, falling loose with its cuff of irregularly ruffled lace! A feast for the eye.

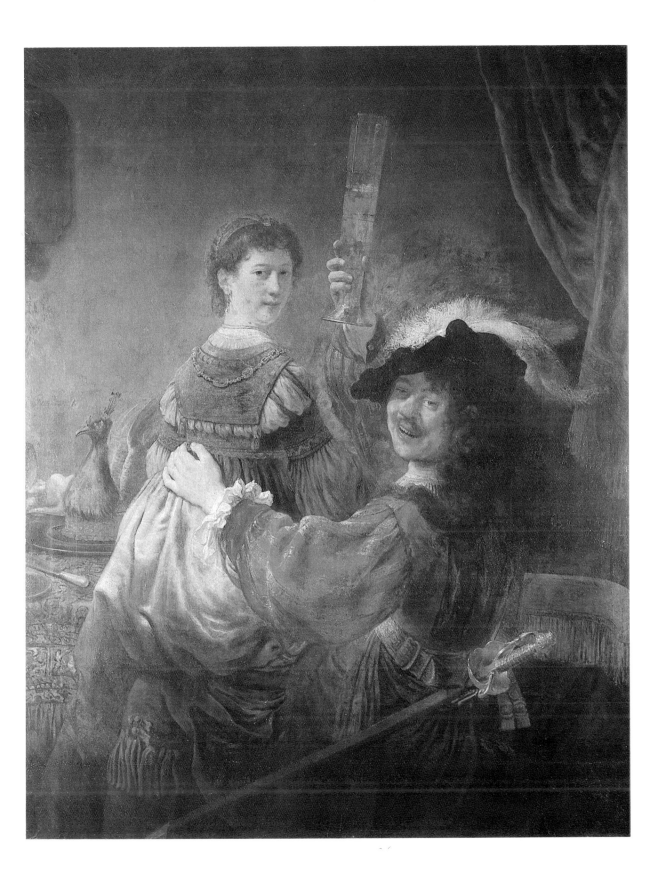

# Flora    1634

No. 16

Canvas, 125 × 101 cm
*Leningrad, Hermitage*

Rembrandt and Saskia van Uylenburgh were married on 22 July 1634 in Sint Annaparochie in Friesland. It is tempting to see representations of Saskia in the pictures of young women Rembrandt painted after that date. The suggestion is often made that she appears here, but it is difficult to determine if this is really the case; the betrothal drawing of 1633 offers too few grounds for certainty.

The pastoral life, the simple life in the tranquillity of Nature, was seen by many people in the seventeenth century as an ideal means of relaxation, far from the stress of daily existence. Poems were written about it, plays were performed, people had their portraits painted as shepherds or shepherdesses, and it was fashionable to appear at parties dressed as Arcadians.

One of the popular tales of the time was the story of Granida and Daifilo, which tells of the shepherd Daifilo and his love, the shepherdess Dorilea. But one day Daifilo met the princess Granida and it was love at first sight. After many complications, Daifilo was made a prince, the lovers could marry and live happily ever after.

This partiality for pictures of country life had probably percolated in from Italy. Painters from Utrecht, who had worked for some time in Italy, had there become acquainted with this kind of picture, and back in the Netherlands they, too, started to devote themselves to representations of shepherds and shepherdesses, with great success. Rembrandt was undoubtedly familiar with such works by artists from Utrecht.

This painting fits into that tradition. But in contrast to the shepherds and shepherdesses who were often dressed very simply, the woman in Rembrandt's painting is dressed in costly clothing of oriental-looking material. Her long dark locks fall halfway down her back; on her hair she wears a garland of flowers, and a tulip – then the most popular flower in the Netherlands – hangs down beside her ear. Her crook, too, is decorated with a festoon of flowers.

Surely, this luxuriously attired shepherdess is no keeper of sheep or goats; she must represent a goddess, perhaps Flora, the goddess of summer, of flower and field, of fertility. In later years Rembrandt made two more paintings similar to this, but in them the women are more provocative, less modest than this lovely girl decked in flowers.

Sometimes parallels have been sought in contemporary theatre for the paintings in which Rembrandt decked out his sitters so fantastically. Is this theatrical costume, and could a more detailed knowledge of seventeenth-century theatre also provide the names of the sitters? So far no-one has succeeded in establishing the connection.

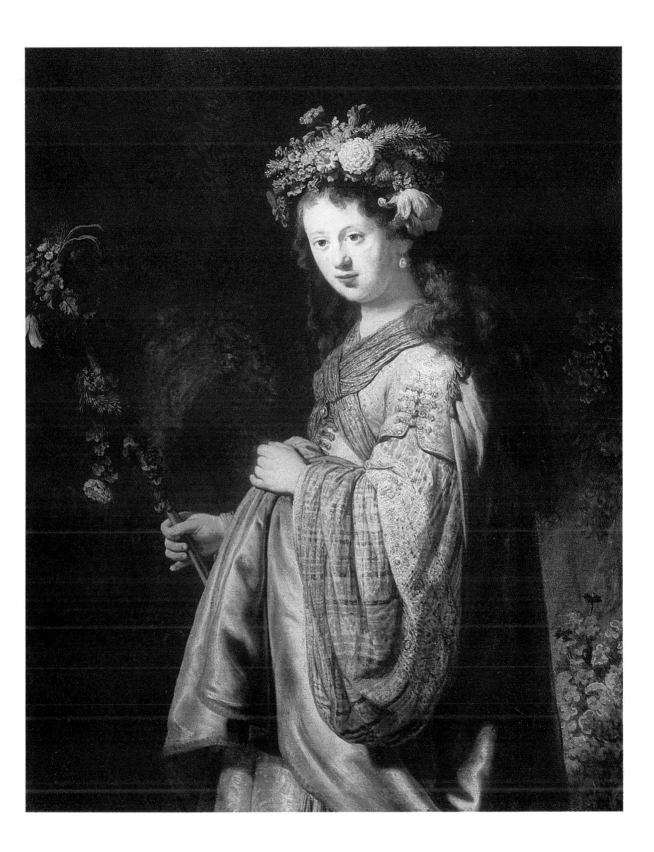

# Dirck Pesser    1634

No. 17

Panel, 67 × 52 cm
*Los Angeles, County Museum of Art*
Pendant of no. 18

Dirck Jansz. Pesser (1587–1651) was a prosperous brewer and active member of the Remonstrant community in Rotterdam. Connections in Amsterdam had probably put him in touch with Rembrandt, who included many Amsterdam Remonstrants among his customers in the 1630s. Though there is documentary evidence that Rembrandt was in Amsterdam in 1634, he would probably have gone to Rotterdam to paint the portraits of Dirck Pesser and his wife Haesje van Cleyburgh (no. 18), rather than they come to him.

The portrait was originally oval, like many of the portraits Rembrandt painted in that period. Some time in the eighteenth or nineteenth century it was enlarged into a rectangle. A difference in colour between the original and the additions is now clearly visible.

Pesser's black clothes and black hat have not been fully worked up. Rembrandt has, however, bestowed much attention on the loose pleats of the white linen collar he is wearing. The shadows are strongest just where the observer in front looks straight into the pleats. Rembrandt also recorded Pesser's greying hair and his slightly darker beard with great care. As so often in Rembrandt's portraits the light comes from the left, shining on his right cheek and his nose with highlights, and leaving the left side of the face rather in shadow.

For his portraits Rembrandt almost always chose a dark ground, which harmonized with the simple colour scheme of the flesh colours of the face, the black of the clothing and the white of the collar. This grey ground is not, however, flat, but alive with a variety of shades of grey and beige. In addition, Rembrandt shows, below right, how the shadow of Pesser's head falls on the wall behind him.

In the painting Pesser is 47 years old. Contrary to his custom, Rembrandt has written the sitter's age to the left of Pesser's head, placing the signature, as usual, on the right, boldly and in full. Portraits of this format, which show only the head and shoulders, were the kind of portrait favoured by the affluent middle class. They gave no opportunity for special poses or unusual composition. But thanks to his exceptional powers of observation Rembrandt's portraits possess a truth to life and a precision which distinguishes them from others of the period.

# Haesje van Cleyburgh     1634

No. 18

Panel, 68.5 × 53 cm
*Amsterdam, Rijksmuseum*
Pendant of no. 17

Haesje Jacobsdr van Cleyburgh (1583–1641) was four years older than her
husband; she married him in 1612. These two facts are just about all that is
known of her. It often seems as if in those days women were more conservative
in their dress than men. Pesser is wearing his collar in loose pleats, while his wife
still chooses the great stiff 'millstone' ruff, held up at the back by a metal frame,
the *portefraes*. She also wears a coronet-shaped cap, made of finely pleated white
linen, of a kind again no longer fashionable when the portrait was painted.

It can be seen plainly in the painting that Rembrandt has extended the collar
on the right in a second attempt, painting over the background. He has strikingly
observed how the colour of the ruff changed depending upon the way in which
one looked at it: looking straight into the folds, one also sees the reflection of the
black dress beneath. On the right side of the ruff can be seen the shadow thrown
by Haesje's head.

At first sight Haesje looks duller than her husband, but close inspection shows
that just the opposite is the case: there is a little smile round her mouth, and
light twinkling in her eyes, in which Rembrandt has even managed to show the
natural moisture.

These were busy years for Rembrandt. Though his ambition of becoming a
history painter must at that time have been pushed rather into the background
by the flood of commissions for portraits, everything indicates that Rembrandt
had not given up his dream. The commissions from Frederick Henry on which
he also had to work must have been opportune, for the market for history
paintings was not large in the Netherlands, since the official church was not
fond of pictures of religious subjects, and the court was modest, which made
commissions from that quarter rare events.

1634 is the last year that Rembrandt and Saskia lived at Van Uylenburgh's. In
1635 they moved to a rented house in the Nieuwe Doelenstraat. Does this mean
that Rembrandt's business relationship with Van Uylenburgh was also coming to
an end?

Rembrandt seems to have been successful as a teacher, too. From these years
stems the story that he had so many pupils that he had to hire a warehouse on
the Bloemgracht to get them all in. Many pupils also meant much money, and
together with the constant stream of commissions for portraits these years should
certainly have been prosperous ones for him.

# The Sacrifice of Isaac    1635

No. 19

Canvas, 193 × 133 cm
*Leningrad, Hermitage*

Abraham and Sarah were severely tried by God: He had promised them a son, but the conception was so long delayed that they had long ago abandoned hope of having children. Only when they were both at an advanced age was Isaac born. But the trial was not yet over. Abraham was ordered by God to go into the mountains and there sacrifice his son Isaac. Abraham obeyed. For three days he travelled with Isaac and two servants to the place that God had named. There he built an altar, laid wood on it, bound Isaac, laid him on the altar, and took the knife to slay him. But there came a voice from heaven which stopped him: Abraham had fully proved his obedience to the Lord's command. Abraham saw a ram in the thicket, and sacrificed it in place of Isaac.

Rembrandt has rendered the event even more dramatically than it is written in the Bible; not only the voice of an angel restrains Abraham, but the angel himself seizes Abraham's hand so that he lets the knife fall to the ground. Particularly the way in which the knife is painted, falling in mid-air, has been widely admired.

Abraham's head is reminiscent of the old men Rembrandt drew and painted during his time in Leiden, with its high wrinkled forehead, tufts of grey hair, the long curly beard. But in other respects Rembrandt's work had changed much since his Leiden days: he was now working on a large scale on a scene full of action, drama, movement, emotion. This is a sophisticated composition in which the body of Isaac bound fast in the foreground is linked logically to Abraham whose hand pushes back Isaac's head. Abraham's gaze is directed towards the red-haired angel, in all its loveliness, bearing the message of deliverance. On the left is a distant vista, giving space for the falling knife and adding to the emphasis upon it.

The light coming with the angel shines fully on the naked body of Isaac, and casts a heavy shadow on Abraham, but the parts of Abraham's body which are important for the story – his face and hands – are fully lit up by it. The shadow is so deep that all the colour has gone from Abraham's green cloak: the green is only visible where it forms a background for the body of the naked boy.

Rembrandt's fascination with light, which he had already displayed in his earliest paintings, has here gained dramatic force. Such drama seems essentially un-Dutch, and Rembrandt must have made grateful use of his knowledge of Italian art, gained primarily from the paintings of the Utrecht 'Caravaggists', who had been to Italy and had there become acquainted with the work of Caravaggio, the great master of light and shade.

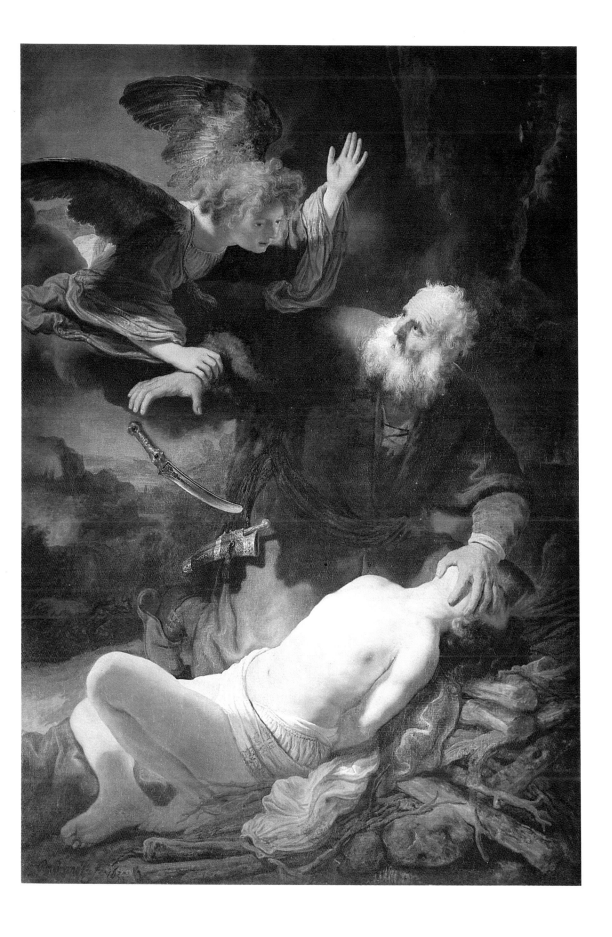

# The angel leaving Tobias
# and his family    1637

No. 20

Panel, 68 × 52 cm
*Paris, Louvre*

Since the Synod of Dordrecht had established in 1619 which books of the Bible would constitute the official Dutch translation of the scriptures, the book of Tobit had been uncanonical. In the first official translation, which came out in 1636, the story certainly appears, but at the back, and in small print. But this had not cost the book of Tobit its popularity. People enjoyed the story which told how Tobit's faith in God was finally rewarded in spite of countless tests.

Rembrandt painted the story of Tobit a number of times (see also no. 4). Old Tobit had been blind for many years, but thanks to the help of a stranger was cured of his blindness. The stranger had been on a journey with Tobit's son, young Tobias, and on the way they caught a fish. From the gall of this fish he had made a medicine and thanks to this medicine old Tobit could see again. But that was not all: the stranger had also provided young Tobias with his wife Sarah, but not until he had seen to it that all the evil spirits which had previously possessed her had been driven out. In spite of all these extraordinary events, no-one in Tobias's family was aware that they were dealing with an angel. They realised only when the stranger had left them. That is the moment Rembrandt pictures here. The angel Raphael flies elegantly up to heaven, and everyone reacts in their own way: old Tobit kneels on the ground, his hands folded, his head bowed; young Tobias looks in bewilderment at his travelling companion; old Anna cannot bear the sight of the angel, but young Sarah does not avert her gaze; the dog, which had accompanied Tobias and the stranger on their journey, barks in surprise at the strange event. The variety of reactions, so different in the young and the old, obviously excited Rembrandt. The book of Tobit tells the story differently: it has the family fall to the ground and remain with bowed heads for three hours.

The angel is flying away not only from Tobias's family, but also from the observer, as if he were moving away into the back of the painting, a bold example of perspective. He is being raised up to heaven on a dark cloud which reaches down to the earth, but inside the cloud it is light, and the light also shines on the family in a subtle way. It gives little edges of light to their clothing, to young Sarah's veil, to old Anna's headcloth, to the slightly drooping neckline of Tobit's cloak, and thus the otherwise rather dark group gains some animation.

In size and support (wooden panel) the picture closely resembles the work of the Leiden period, but is more daring in composition and more subtle in execution than the paintings of that time.

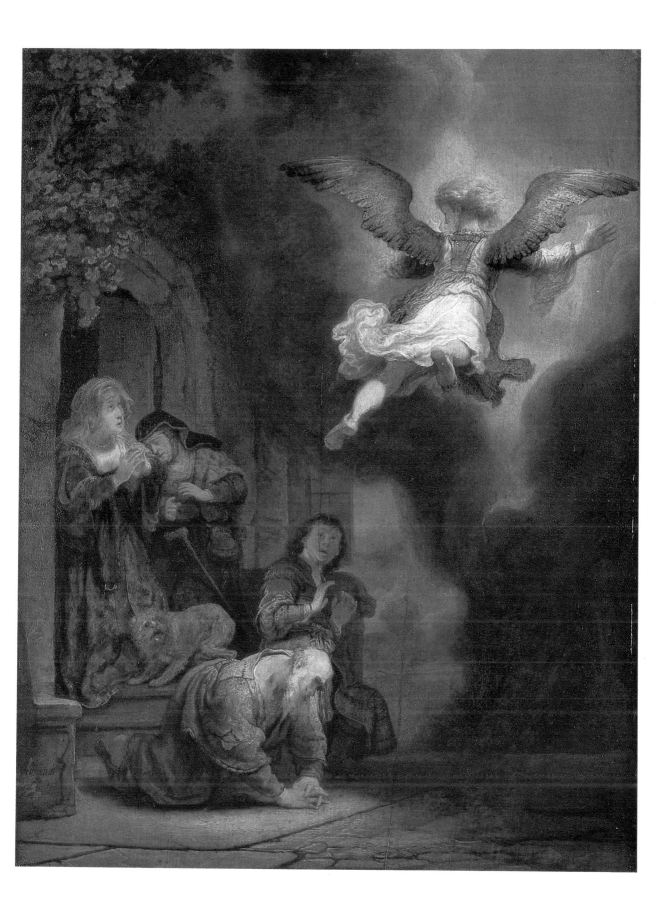

# Landscape with a stone bridge    $c1638$

No. 21

Panel, 29.5 × 42.5 cm
*Amsterdam, Rijksmuseum*

Rembrandt was, on the evidence of his drawings and etchings, an enthusiastic walker in the countryside. But in the few landscape paintings by him that are known, he does not generally represent the countryside around the places where he lived, or any existing landscape. Even when it is a question of a true Dutch landscape – it is thought that the surroundings of Oudekerk on the Amstel can be recognised in the *Landscape with a stone bridge* – still Rembrandt depicts it in a way in which anyone walking along the Amstel would rarely have seen it, with wild clouds, thick groups of trees, a dark stream, a sharp alternation of light and shade. As in his history pictures and also in his portraits, Rembrandt goes for drama, even in a landscape.

In the seventeenth century open country was very near at hand for the citizens of Amsterdam. The construction of the great girdle of canals of the Herengracht, Prinsengracht and Keizersgracht was only completed at the end of the seventeenth century; until then the Singel was the outward limit of the city. Nobody therefore had to walk more than fifteen minutes to reach one of the city gates.

A landscape with so much drama in it might in fact be more than just a landscape. Some see a message, a lesson for the Christian way of life, in this painting, and in many other seventeenth-century landscapes. They recognise all kinds of symbols in the picture, which are also used in religious texts and sermons of the period.

In this way the bridge over the river would be a symbol for Christ, the only road which leads man safely through life, represented by the river. On the left of the picture can be seen a tavern, recognisable by its hanging sign. In front of the tavern is a coach; the passengers have alighted and gone into the tavern. They have not followed a Christian way of life, they have made the wrong decision. The traveller who is just approaching the bridge in the streak of light is wiser. He bears his sins in the bundle on his back, and with this burden approaches the bridge, the bridge which will take him over to the other side, past the ancient trees and the old gate, symbols of the transitoriness of life. His final goal is to be seen on the far right of the painting, the church, in other words Heaven.

Those who look at the picture would be meant to take to heart the lesson that the right road leads over the bridge. If that indeed was the message which Rembrandt wanted to present in his painting, then he has certainly used the light most evocatively: the way the light falls focusses attention on the road over the bridge.

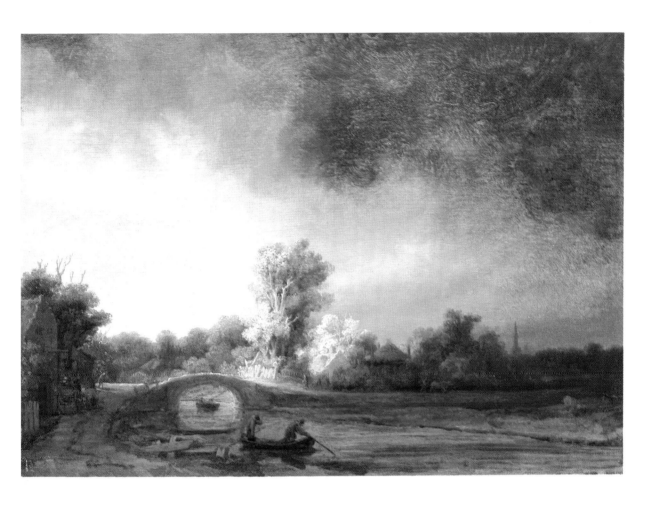

# Samson's wedding    1638

No. 22

Canvas, 126 × 175 cm
*Dresden, Gemäldegalerie*

Samson, an Israelite, married a woman from the enemy camp, a Philistine.
During the marriage feast Samson set his guests a riddle: 'Out of the eater came
forth meat, and out of the strong came forth sweetness'. Samson is sitting to the
right of the table, surrounded by a group of wedding guests, and adding force to
that riddle, so full of contradictions, by his gestures. The guests had seven days
to solve the riddle, but it was too difficult for them. They therefore decided to
cheat Samson out of his secret through his young bride. She succeeded in
coaxing Samson into telling her the answer: he was talking about the lion he had
killed with his own hands, and in whose body he had later found a honeycomb.
The Philistine girl told the story to her countrymen, and they came triumph-
antly forward to volunteer the solution. Samson realised immediately that his
wife had betrayed him, since she was, after all, the only person to whom he had
told the story of the lion. He was furious, and in revenge slew 30 Philistines.
Rembrandt's representation of the telling of the riddle also suggests the outcome
of the story: it is obvious that the bride is a woman with a will of her own.

After this venture miscarried, Samson chose another woman of the Philistines,
Delilah. But with her, too, the demands of her race weighed more heavily than
her love for Samson. She, too, enticed Samson, at the request of her kinsmen,
out of a secret: wherein lay his great strength? In his long hair, answered
Samson, and so Delilah made him drunk, and while he was sleeping in her lap,
cut his hair. That was the end of Samson's strength, and the Philistines were
finally able to overpower him.

Rembrandt took every pain to make the marriage feast as animated as
possible: the guests are placed in groups next to each other, not sitting on chairs,
but reclining beside the table, in oriental fashion, on couches. The group is cut
off on the left by a couple who are seen from behind. On the right there is a view
of the area where the story is happening: Samson, with his long hair, surrounded
by guests asking questions. In the middle is the bride, aloof, sitting apart from
the others in the place of honour in front of a tapestry.

Rembrandt took great care to make his pictures look as authentic as possible.
Information about oriental customs and usages had always greatly interested
him. Rembrandt perhaps knew that in the East men reclined at table and did not
sit from an authentic source, a painting by the Dutch court painter of the Shah of
Persia, Jan van Hasselt.

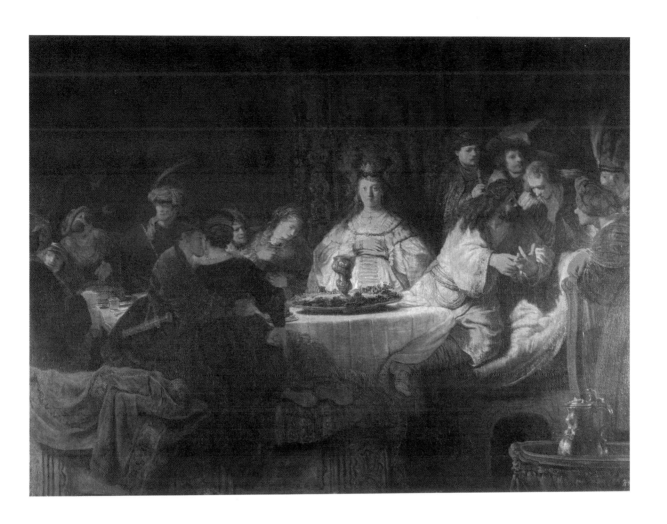

# Maria Trip    1639

No. 23

Panel, 107 × 82 cm
*Amsterdam, Rijksmuseum* (on loan from the *Van Weede family Foundation*)

Maria Trip (1619–83) was a rich heiress and an attractive match. When Rembrandt painted her portrait she was twenty years old, and thus of marriageable age, but it is not known whether her having her portrait painted had anything to do with finding a suitable candidate for her hand. Rembrandt portrayed her in all the glory of a rich merchant's daughter, in black, it is true, but her dress is of a luxury exceptional in sober Amsterdam. She is fashionably attired in a dress with a high waist, a flat collar of many layers, and wide sleeves. Collar and cuffs are made of extremely fine transparent lawn and decorated with wide strips of lace. Even more costly is the lace out of which the bands and rosettes on her skirt are made, since it is interwoven with threads of pure gold. Maria's wealth is also apparent from her jewellery: a string of large pearls on her neck, four strings of smaller pearls on each wrist, a golden brooch with diamonds and pearls on her breast, and matching drops in her ears. Not least Maria's coiffure is in high fashion, half length, combed out wide, ringlets by her ears, and at the back of her head a chignon decorated with a precious jewel.

For this luxurious portrait Rembrandt chose an appropriate background, not his usual smooth grey wall, but an arch of natural stone, a passage or a doorway, adding the impression of a wealthy setting.

Maria's father, Elias Trip, had with his brother Jacob (see no. 51) and Lodewijk de Geer, his brother-in-law, founded a lucrative trading company: among other things they owned iron mines and arms factories, and were financiers. When her father Elias died in 1631 the family lived in a spacious house on the Oudezijds Voorburgwal, close to the Grimburgwal. Amalia van Solms, the wife of Stadtholder Frederick Henry, went to stay there in 1638 when she accompanied Marie de' Medici, the French Queen Mother, on her state visit to Amsterdam; this is a clear indication of the high status of Trip's widow, since Amalia was particular when it came to consequence or connection. Was it this contact of Trip's widow with court circles that caused her to commission portraits? The question arises because in 1639 Rembrandt not only received the commission to paint Maria, he also made a portrait of the widow herself, Aletta Adriaensdr (now in the Boymans-van Beuningen Museum, Rotterdam).

Rembrandt had previously produced a drawing to show what Maria's portrait would look like, as was the normal procedure with portraits; once accepted, the drawings would often serve as an official confirmation of the commission. These advance drawings have rarely survived, but Maria's is preserved in the British Museum, London. Drawing and subsequent portrait are almost identical in design. Only the handkerchief held by Maria in the drawing has been replaced in the painting by the handle of a fan with an expensive ribbon falling half over Maria's hand – increasing still further the sophistication of the portrait.

Maria married two years after the portrait was made. The bridegroom was Balthasar Coymans, a rich Amsterdam merchant, brother-in-law to her sister, and exactly 30 years older than Maria herself.

The portrait is still in the ownership of Maria's descendants, but has been on loan for nearly a century to the Rijksmuseum.

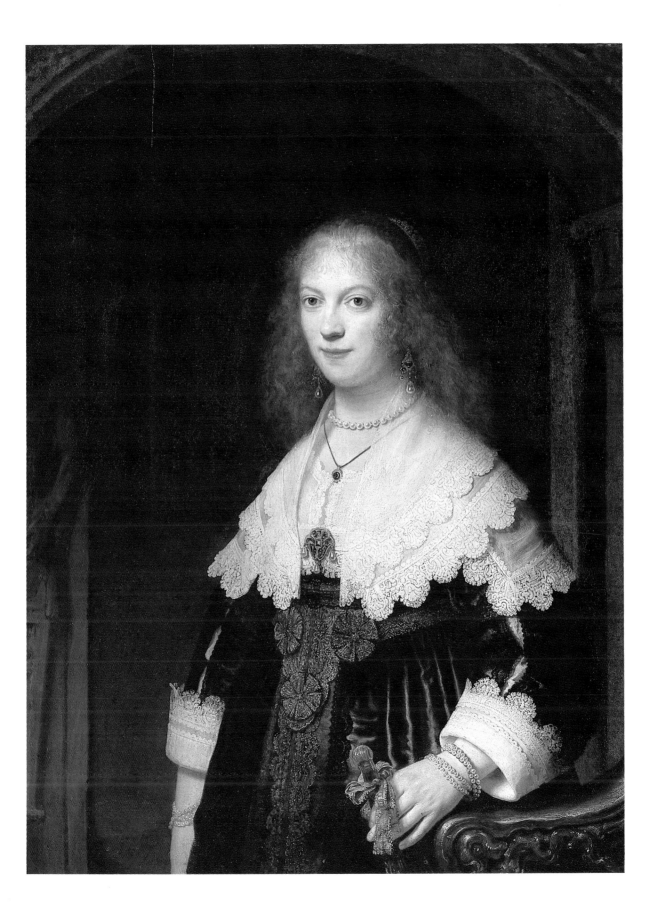

# Still life of peacocks with a girl    *c*1639

No. 24

Canvas, 145 × 135.5 cm
*Amsterdam, Rijksmuseum*

Still lifes proper, in which everything shown is inanimate, were never painted by Rembrandt. He was so much interested in action in a painting, that the true *nature morte* would have meant nothing to him. Even so, the paintings of his Leiden period show that he was fully aware of what his contemporaries in the town were achieving in the genre. Some parts of his paintings of this period stand comparison well with the *vanitas* still lifes, still lifes of objects indicating the transitoriness of life, which were at that time a speciality of Leiden.

This painting, too, relates closely to the genre of still life. Still lifes of game were popular in the seventeenth century especially in those circles where hunting was a recreational pursuit. These pictures appealed to purchasers probably especially because they were illusionistic, because it looked just as if a real dead hare lay on the table, or a dead swan hung from a peg. This taste encouraged jokes in paint, such as a note pinned on to the picture, a curtain painted into it, or a fly settled on a flower.

Although it is obviously in the tradition of 'game-bag' paintings, by adding the girl who is looking out of the window at the two dead peacocks, Rembrandt has made the picture into something more. Peacocks were not mere game, but were an exceptionally costly party dish, which would be served with appropriate panache: for example, on top of the pie a stuffed peacock might be placed, displaying all its fine feathers. Modern culinary experts doubt that peacock was particularly good to eat – it was probably dry and tough – but that would have been of minor importance in a presentation of this kind.

The painting does not owe its realistic appearance to the precision of its execution. During this period Rembrandt began to experiment with a freer style of painting, in which he paid more attention to the total impression than to meticulous reproduction. This can be clearly seen here: close inspection reveals that the glory of the birds' feathers is indicated rather than worked out in detail, even though the effect is as realistic as could be, aided by the dramatic light and shade.

In the years to come Rembrandt was steadily to develop this manner of dealing with his subjects. He became a painter who did more than reproduce reality so that it was true to life; he got right through to the essence of things.

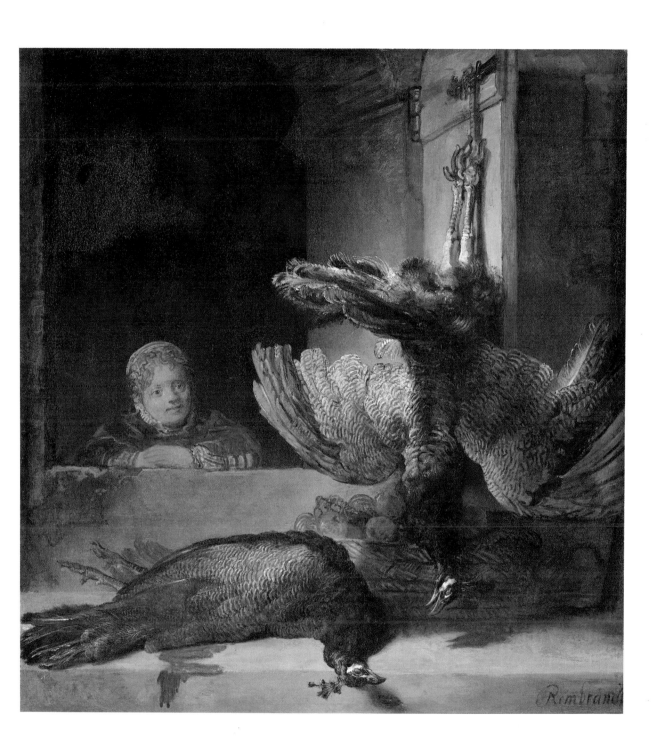

# The Visitation 1640

No. 25

Panel, 56.5 × 47.9 cm
*Detroit, Institute of Arts*

Elisabeth and her husband Zacharias were both old and had long given up hope of having children. But an angel appeared to Zacharias when he was busy in the temple – he was a priest – and informed him that he and Elisabeth would have a son whom they should name John. This John would proclaim the coming of Jesus, convert and baptize the people, and would acquire the name of John the Baptist. A few months after Zacharias's vision an angel also appeared to Mary in Nazareth, to announce that she would be the mother of Jesus, and also told Mary that her cousin Elisabeth was pregnant. Mary immediately set out for Jerusalem to visit Elisabeth. Their meeting, the subject of this painting, is usually called the Visitation.

Rembrandt has set the meeting in luxurious surroundings, by an impressive house, with steps up to it, imposingly sited with a view over Jerusalem. Mary is surrounded by servants – a negro girl taking off her cloak, and an older man leading away the ass. The light comes from above right, and illuminates the group on the steps, making clear what the most important event is in the painting: the light shines from one side on the dignified figure of young Mary, and falls full on Elisabeth's arms as she embraces Mary and on Elisabeth's aged face under her head-scarf, a facial type with which we have been familiar since Rembrandt's Leiden period. Not merely an adroit painter, Rembrandt was also a master of composition: in spite of its rather small size, the painting makes a monumental impression.

The panel was probably originally rectangular, and at a later date was cut to make it, in accordance with the taste of the time, semi-circular at the top; this has also happened to other Rembrandt paintings.

The painting dates from 1640, following many changes in Rembrandt's personal circumstances. He had bought a large house in Sint Anthoniebreestraat, next door to Van Uylenburgh's where he had lived during the early years of his stay in Amsterdam. The house cost 13,000 guilders, which he could not pay in a lump sum, but was to pay off within six years. The undertaking certainly demonstrates confidence in his future. The house had a roomy studio where Rembrandt could work and space for his steadily growing art collection. In 1640 Rembrandt and Saskia's third child, Cornelia, was born, but she died in infancy, like their two previous children. Also in 1640 Rembrandt's mother died in Leiden. She was then about 72; it is doubtful whether Rembrandt had seen her since he left Leiden. The inheritance was divided between Rembrandt and his brothers and sister; Rembrandt's share consisted of personal effects to the value of a few thousand guilders.

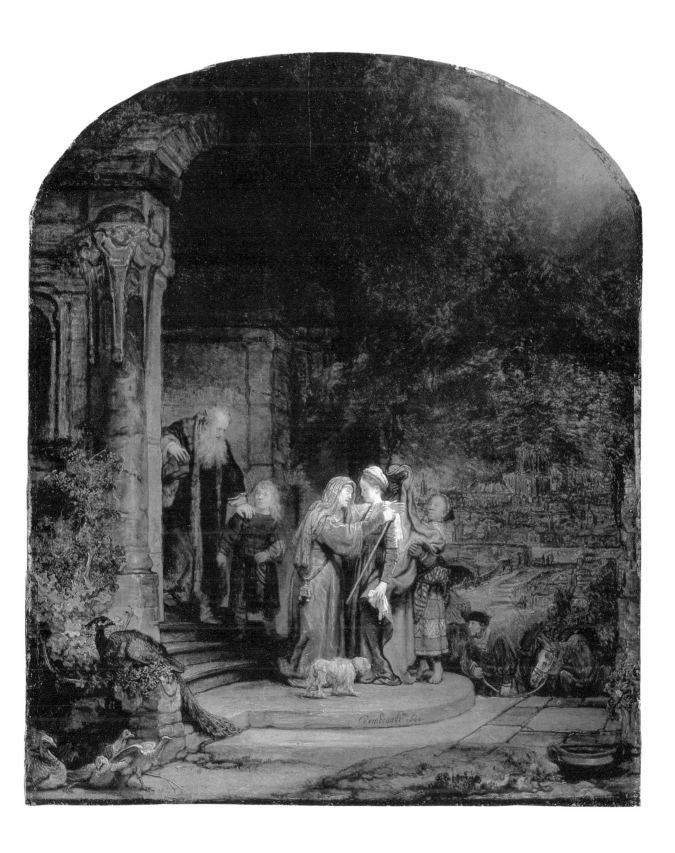

# Self-portrait    1640

No. 26

Canvas, 102 × 80 cm
*London, National Gallery*

Alfonso Lopez, a rich Spanish merchant and an enthusiastic collector of Italian art, was agent in Amsterdam for the French King Louis XIII, and dealt among other things in gold and diamonds. When on 9 April 1639 there was a sale in Amsterdam of Lucas van Uffelen's collection of Italian paintings, it goes without saying that Lopez was there. What he bought was no trifle, Raphael's portrait of Baldassare Castiglione (now in the Louvre in Paris). Rembrandt, too, was present at the sale: he made a sketch of Raphael's portrait, and noted on it that the painting had become Lopez's property for 3500 guilders.

Perhaps Rembrandt also visited Lopez's house on the Singel, since another painting from his collection had made a great impression on Rembrandt, Titian's portrait of a man with a blue sleeve, often regarded as a self-portrait, now in the National Gallery in London.

Rembrandt, in painting his own self-portrait, drew on both these outstanding Italian models: it is doubly a portrait in the Italian style, since Rembrandt did not represent himself dressed in contemporary clothes, but in sixteenth-century Renaissance attire, like that worn by Castiglione in Raphael's portrait. Titian's blue was not Rembrandt's colour; what appealed to him was the pose of Titian's portrait, the elbow supported on a stone balustrade, with the sleeve falling broadly across it.

The painting was probably made circular later, from an original rectangle. The way in which Rembrandt had placed his figure in the picture space, as he often did, with the head not in the centre, but displaced slightly to the left, would then have been more apparent.

Rembrandt used the same pose for an etched self-portrait in 1639, and for a number of other portraits commissioned from him in those years.

It is an impressive self-portrait of the painter who was now 34. Rembrandt was someone in Amsterdam; he was a popular teacher, he was much in demand as a portrait painter, he had a large house, he was married to a wife of good family, he had connections with all sorts of important citizens, and he received commissions from the Court in The Hague. The painter who only nine years earlier had moved from Leiden to Amsterdam had made a good career for himself.

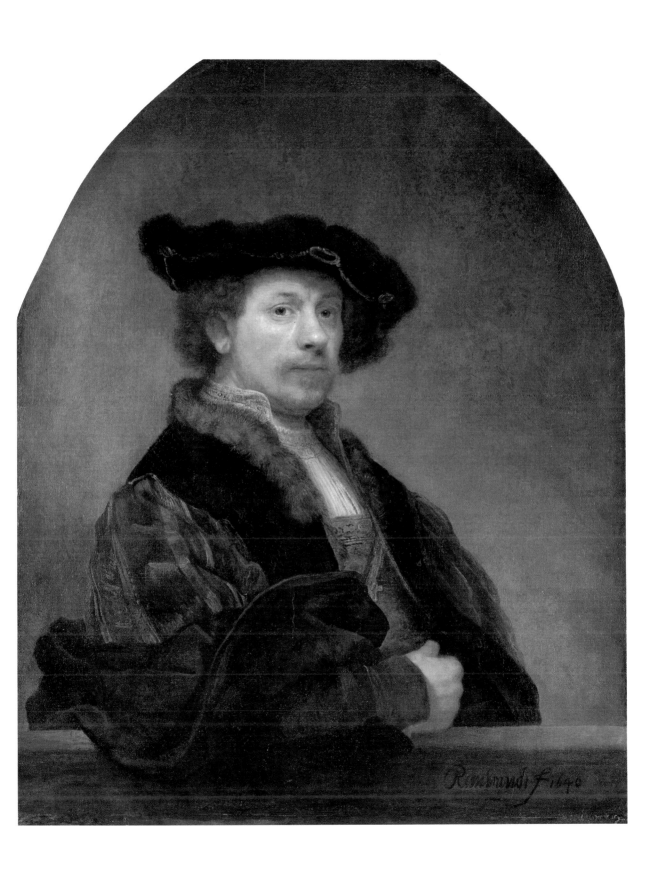

# Saskia with a flower   1641

No. 27

Panel, 98.5 × 82.5 cm
*Dresden, Gemäldegalerie*

To the great surprise of Constantijn Huygens, who mentioned it in his autobiography, Rembrandt told him in 1629 that he did not think it necessary to complete his education with a trip to Italy, as so many painters did at that time. Huygens, impressed more than anyone with the importance of classical antiquity and the achievements of the Italian Renaissance, could not conceive of such arrogance.

But, though Rembrandt thought such a trip to Italy unnecessary, he was certainly interested in Italian art. He was familiar with the collections of Italian art in Amsterdam, and with what came on the market there, and he collected prints of the work of a large number of Italian artists. In his own work his interest in his Italian brothers-in-art can be repeatedly recognised in the way he composes specific subjects, dresses his figures, and certainly, too, in his use of the kind of *chiaroscuro*, or strong light and shade, that had become so popular in the Netherlands through the influence of the Utrecht Caravaggists, painters like Hendrick Terbrugghen, Dirck van Baburen, and Gerard van Honthorst. Rembrandt was undoubtedly familiar with their work.

In this picture, which is usually considered to be a portrait of Saskia, the Italian influence is unmistakable. In the same collection by Lopez to which the Raphael and the Titian (see no. 26) belonged, there was a *Flora* by Titian (now in the Uffizi in Florence) in which a woman in a loose white robe offers a flower to the observer. Saskia is making the same gesture in this portrait, but the dress is different, less free than in Titian. However, it is not normal seventeenth-century dress, but a fancy costume derived from sixteenth-century models.

It could well be that this portrait belongs with the 1640 self-portrait in the Italian style (no. 26). The balustrade on which Rembrandt rests his arm so elegantly can be seen here behind Saskia. These would still be unusual portraits. Do Rembrandt and Saskia perhaps represent not themselves, but historical or allegorical figures, perhaps a poet with his muse, or a prince with his mistress? So far it has not been possible to answer this question.

This is the last portrait of Saskia. In 1641 Titus was born, Rembrandt and Saskia's only child to survive, but Saskia herself died less than a year later; she was just 30. It is thought that she suffered from tuberculosis, and that that is why she and her children died so young (Titus died aged 27). She left her capital to Titus; Rembrandt enjoyed only the income from it.

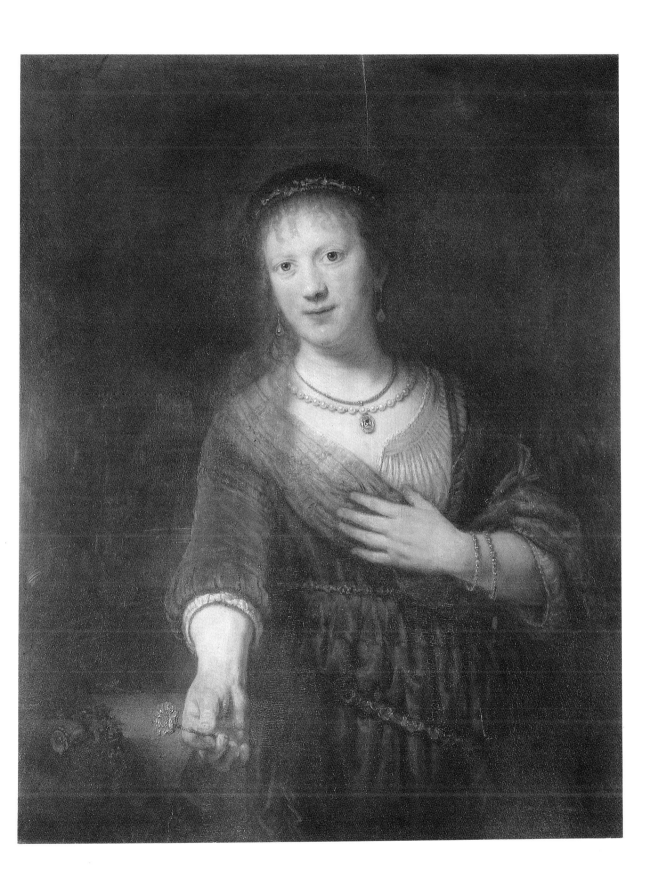

# Cornelis Anslo with his wife Aeltje Schouten, or with a parishioner 1641

No. 28

Canvas, 176 × 210 cm
*West Berlin, Staatliche Museen*

Cornelis Claesz Anslo (1592–1646) was a successful merchant, as is plain to see from this portrait. He was also a Mennonite (a member of the Baptist sect led by Menno Simonsz) and acted as minister in the same community to which Hendrick van Uylenburgh belonged.

Mennonites were known for their simple way of life, which was also expressed in their sober dress: lace was sinful, collars and cuffs must be discreet, clothing black. Simple, however, was not synonymous with shabby, as can be seen from the handsome fur collar on Anslo's cloak, probably acquired in the course of his trade with the Baltic countries.

The Bible occupied an important place in Baptist preaching, and therefore Rembrandt has given the Bible a central position in the painting. He has set the Bible full in the light, brilliantly framed by the costly tablecloth and the folds of the oriental rug draped over it. This luxury seems rather contrary to Mennonite simplicity, but in this arrangement the table with the books on it forms a perfect counterweight to the more static right half of the painting.

Anslo is proclaiming the Gospel from the Bible; he is pictured speaking, his mouth half open, his hand outstretched to give force to his words. But who is he speaking to? According to family tradition this is a portrait of Anslo and his wife Aeltje Gerritsdr Schouten (1598–1657). A 1767 document written by a great-grandson of the couple, Cornelis van Vliet, calls it their portrait and describes how Cornelis also expounded the Gospel within his own family.

But Aeltje Schouten is very humbly pictured, and looks rather old for her 43 years. For this reason it has also been thought that the great-grandson was mistaken, and that Anslo is pictured with one of his flock, for example a widow needing comfort, or with one of the poor and aged domestic servants for whom Cornelis Anslo's father had founded a home. Could the painting perhaps have been intended for the board room of the home? But there is the difficulty that the woman is rather too well dressed for a poor servant, with her black silk dress and fur-trimmed cloak.

If the woman is not Aeltje Schouten, but an anonymous old woman, the two candles on the table could be explained in the following way: the left-hand candle stands for Anslo, at 49 far from being burnt out, the right-hand one for the old woman who is nearly at the end of her life. The snuffers lying next to the left-hand candle would indicate the duty which was particularly stressed by the Mennonites, the *correctio fraterna*, the task of showing your neighbour his faults, and helping him to live a better life. Since the Mennonites had no office holders in their church, this was a task imposed upon every member of the community. Just as a candle will burn better if it is snuffed, so by admonishment a man can lead a better life.

Rembrandt was not merely a painter of likenesses, but sought continually to show action in his portraits. Here he has succeeded superbly: the light, picking out the Bible on the table, also falls on Anslo's hand as he gestures, and on the attentively listening woman, so that the underlying subject of the picture, the preaching of the word, is the main focus of attention.

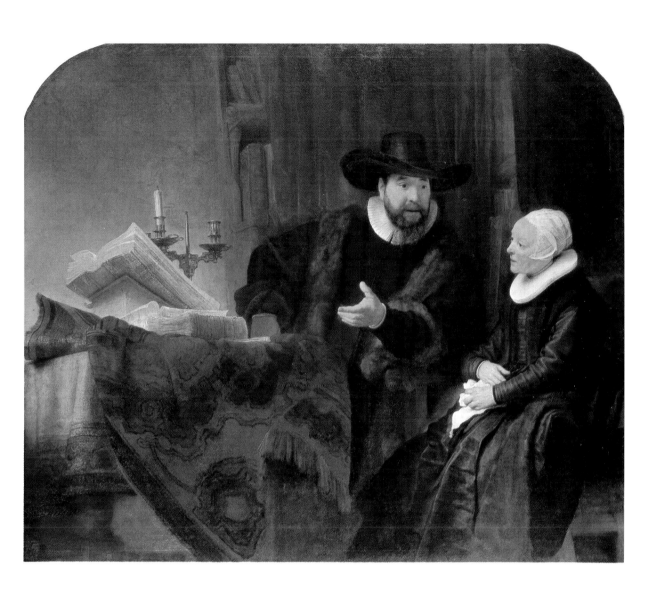

# The company of Captain Frans Banning Cocq and Lieutenant Willem van Ruytenburgh ('The Night Watch')  1642

No. 29

Canvas, 363 × 437 cm
*Amsterdam, Rijksmuseum* (on loan from the *City of Amsterdam*)

The entry of Marie de' Medici, the French Queen Mother, into Amsterdam in 1638 was a great event for the militia companies, who took extensive advantage of the opportunity to put on a show. Perhaps inspired by the pomp and circumstance of that occasion, the militiamen of the Arquebusiers Guild decided shortly afterwards to decorate the new assembly hall of their headquarters with a series of pictures. Each company was to have a portrait made of its own group; above the mantel was to be a group portrait of the senior officers, the *Doelheren*.

The commissions for the paintings went to six different painters, Captain Frans Banning Cocq's company falling to Rembrandt. Apart from Captain Cocq and Lieutenant Willem van Ruytenburgh, sixteen other militiamen wanted their portraits included, each paying a sum of about a hundred guilders – some slightly more, some less, depending upon where they were placed in the final picture. The shares of the Captain and the Lieutenant were of course the greatest.

In Frans Banning Cocq's family album there is a drawing of Rembrandt's group portrait, accompanied by a precise description: 'The young squire of Purmelant (Banning Cocq) as Captain orders his Lieutenant, the squire of Vlaerdingen (Van Ruytenburgh), to advance his company.' It is an action picture, for that was what Rembrandt wanted – not a stiffly posed, artificial head count, as these pictures so often turned out to be.

Rembrandt kept the painting dark, because where there is darkness, light can be provided: on the Lieutenant's yellow gold uniform, on the little girl in the second row. Exaggerated by a deteriorating varnish, this darkness caused the picture to be called the 'Night Watch' in the eighteenth century. Since the restoration of the painting, when all the old varnish was removed, it is quite plain that, for all the shadow, it is actually a 'day watch'.

Rembrandt subtly incorporated a number of facts about the militia company into his painting. The Arquebusiers from time immemorial had used firearms as their weapons, first arquebuses and later muskets. Accordingly Rembrandt worked into the picture the various actions necessary for the use of a musket: the man in red in the left foreground is charging his musket with powder, just behind Van Ruytenburgh's head a musket is being discharged, and a man on Van Ruytenburgh's right is cleaning his musket by blowing the powder out of the pan. Because of the pun upon the sounds *klover* (arquebus) and *klauw* (talon), the Arquebusiers bore two bird's talons in their coat of arms: hence the chicken with its talons hanging from the belt of the little girl, the company's mascot, who also carries the company's silver drinking horn, just visible beside her head.

On the shield above the gate are the names of the militiamen portrayed by Rembrandt, nineteen in all, since the drummer was allowed to be included without payment. Two of them are no longer present, since the left edge of the painting was cut off in the early eighteenth century, when the *Night Watch*, together with the other militia paintings, was transferred to the Amsterdam Town Hall. The place that had been reserved for the *Night Watch* was a little too small, and the picture was trimmed on three of its sides.

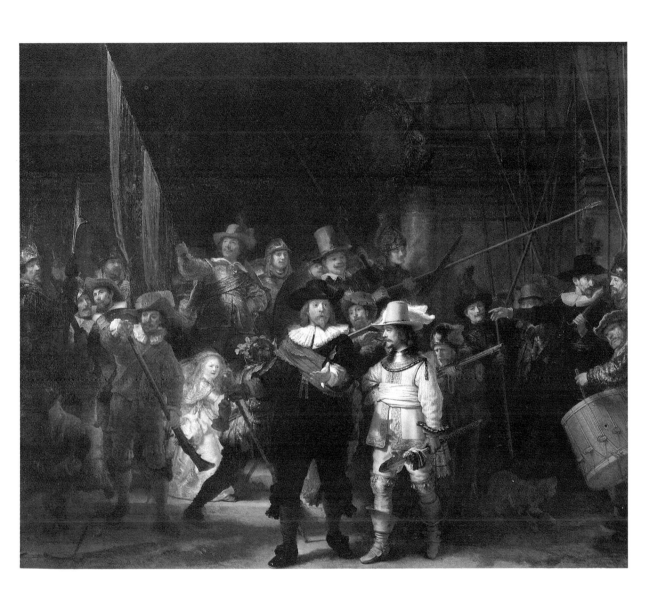

# Danaë   1636–c1643

No. 30

Canvas, 185 × 203 cm
*Leningrad, Hermitage*

Danaë was imprisoned in a room in a tower after her father, Acrisius, King of Argos, had had a prophecy from an oracle that Danaë's son would kill him. But Jupiter, ruler of the gods, a master at adopting alien forms, visited Danaë disguised as a shower of gold. Perseus was born as the result, and the oracle's prophecy fulfilled.

Danaë is lying in a gold-canopied bed, with golden curtains, her legs still partly covered by a sheet. Cupid, all gold, is crying at the head of the bed, his hands bound, so that he cannot use the bow and arrows with which he has contrived so many amorous bonds. But the old serving woman, a bunch of keys on her wrist, is already raising the curtains of the bed to assist the divine visitor. Danaë turns her body away from the light, but shows by a gesture of her arm that the visitor is more than welcome.

Undoubtedly Rembrandt knew, if only through the medium of prints, how the Italians had represented the story of Danaë. Pictures of feminine nudity were generally much more common in Italy. In the north, apart from Eve, only Susannah and Bathsheba, also from the Old Testament, were usual subjects. In his representation of Danaë, Rembrandt closely followed Italian example: the bed, the old maid and Cupid all derive from Italian paintings. Rembrandt modified only the shower of gold, which the Italians usually represented in the form of tangible gold coins, transforming it into a ray of gold-coloured light, which Danaë accepts with some hesitation. The slippers in front of the bed are a typical Dutch attribute: in a great many seventeenth-century paintings they are an allusion to an erotic event.

The painting is one of the largest Rembrandt ever made. It was originally even larger, but sections have been cut off, particularly on the left and at the bottom. Rembrandt probably began painting it in 1636 (the last digit in the date on the painting is rather dim). But from X-rays, which can reveal the paint below the top layer, it appears that Rembrandt made some alterations to the painting some ten years later: Danaë looks down more than she did, she has lost the earrings and two strings of pearls round her neck she had originally, her right hand was positioned rather lower, and there were jewels on the table by the bed, now painted out; the face of the old serving woman was originally more in profile.

Perhaps these alterations were made because Rembrandt had the painting in stock for so long. When in 1656 an inventory was made of Rembrandt's possessions, the official found a 'large Danaë' in the big art room on the first floor. That may not, however, have been this painting, or even a painting at all, but a sculpture.

In 1985 this painting was badly damaged when a bottle of acid was squirted at it. To return the picture to something like its previous state, a restoration lasting several years was reported to be necessary.

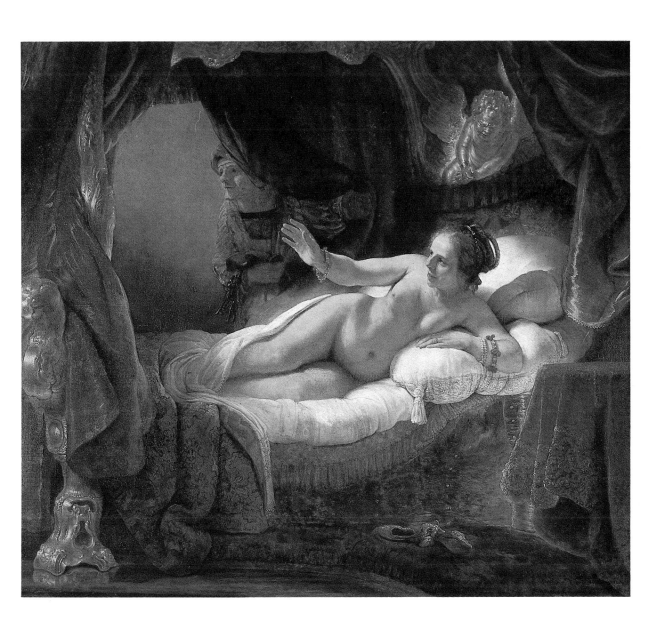

# The Holy Family  1645

No. 31

Canvas, 117 × 91 cm
*Leningrad, Hermitage*

A domestic scene, like so many there might have been in the seventeenth century, in a simple interior, a room in which people both lived and worked. The daylight is excluded. By the fire sits a young woman with a book in her lap, looking into the wicker cradle in which a baby lies sleeping peacefully under a red baize blanket. His father is standing further back in the room beside a work bench, holding an axe, and a brace and bit can be seen hanging on the wall.

But this is no ordinary domestic scene, because there are plump little cherubs who come floating down from somewhere up on the left: this is the Holy Family, the Christchild is in the cradle. Mary and Joseph do not appear to be aware of what is happening behind them, or of the light descending from heaven with the cherubs, falling on the child and outshining the fire on the hearth.

The scene closely resembles the many drawings Rembrandt made over the years of his own domestic environment. To be able to paint a child so deeply asleep, he must have observed a child asleep often and closely. For the cherubs Rembrandt probably used inanimate models, the plaster or wooden *putti* which dangled from many studio ceilings.

It can hardly be accidental that Joseph is busy making a yoke. In fifteenth- and sixteenth-century pictures of the Holy Family, Joseph is often depicted working on something that refers to the future of the child in the cradle: for instance a mousetrap, a symbol of the sins which, thanks to Jesus, will no longer work their destruction. Is the yoke perhaps a reference to the heavy burdens Jesus will have to bear?

Since Saskia's death in 1642 much had changed in Rembrandt's personal circumstances. To care for Titus he had taken a widow into service, Geertje Dircx from Edam. There is documentary evidence that she soon became more than a children's nurse: in 1648 she accused Rembrandt at law of breach of promise. A long and unsavoury quarrel ensued, in part fought out in court, and ending only with Geertje's death in 1656. But none of this was yet obvious in 1645. There were certainly indications that all was not well with Rembrandt's finances. His income could not cover his expenses and his obligations, and in spite of the 1639 contract the house was not yet paid off. By virtue of her will, he could not draw on Saskia's inheritance.

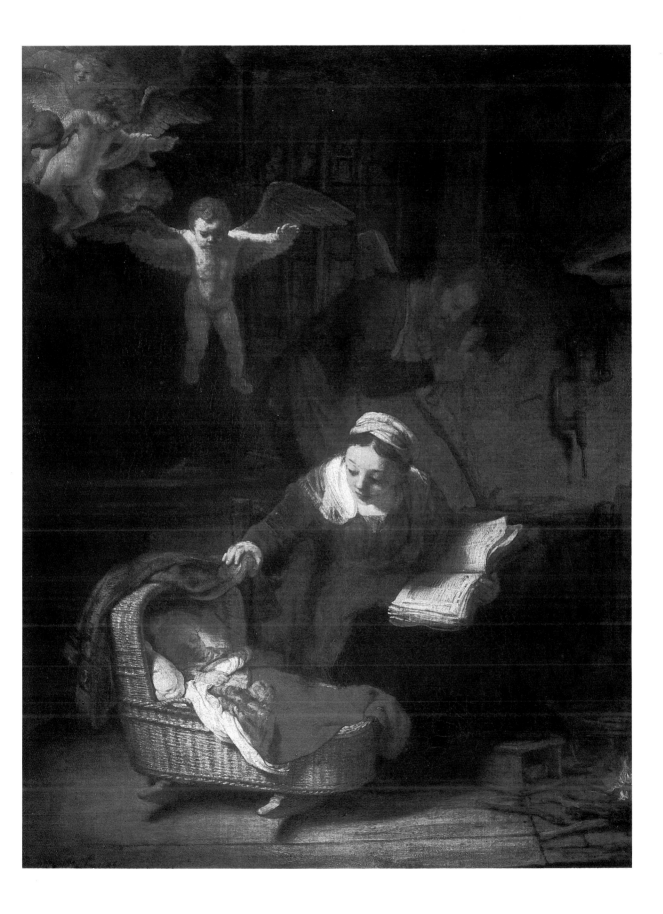

# Dr Ephraim Bueno  *c*1647

No. 32

Panel, 19 × 15 cm
*Amsterdam, Rijksmuseum*

This small picture, twice the size of a picture postcard, of the Jewish doctor and writer Ephraim Bueno (or Bonus, 1599–1665) is not a portrait in the true sense of the word, but a study for an etching Rembrandt made of Ephraim Bueno in 1647. In the 1630s and 1640s, besides painting portraits, Rembrandt developed an important range of portrait etchings. Etchings had the advantage that they could be printed in an edition of more than one copy, and the customer commissioning them therefore acquired a useful gift which he could distribute at home and abroad. Preliminary studies for etchings were usually done in oils, but only rarely, like this one, in colour. They were mostly grisailles, sketches in oils in shades of grey or brown. In making an etching it was, after all, not the colours which were most important, but the different shades of light and dark, and that could be particularly well indicated in grisaille. The preliminary studies for etchings were working documents, and, like preliminary drawings, have usually disappeared in the course of time.

Dr Ephraim Bueno originally came from Portugal, but had left, like so many Jews, because of the Inquisition. After taking his doctorate in Bayonne, he came to Amsterdam, where many Jews from Spain and Portugal had already established themselves over the years. In the northern Netherlands there was greater religious freedom, and Jews could practise, provided they did not do so too conspicuously. The Jewish community had a measure of independence – their own civil courts, their own schools, their own poor relief and their own publishing houses. Their synagogues were originally more or less 'underground' churches, but this changed as the Jews gradually became more established. In 1639 the synagogue on the Houtgracht was substantially enlarged, with the amalgamation of three Portuguese Jewish communities. In 1642 the Stadtholder Frederick Henry paid it a visit, a sign of the official acceptance of this section of the population. There were still barriers, however: not every Jew could become a registered citizen, some professions were closed to Jews, and the guilds did not admit Jews to ordinary membership.

The Portuguese synagogue on the Houtgracht was close by Rembrandt's house, and many of the Jews of Portuguese origin lived in his neighbourhood. That Rembrandt had contacts among the Jewish community can be seen not only from this portrait of Ephraim Bueno, but also from the fact that he made illustrations for the books of the leading Jewish printer Menasseh ben Israel, and in 1636 etched his portrait.

The etching Rembrandt made of Ephraim Bueno is larger than the small painting; the pose is identical, but in the print the banister on which Bueno is resting his arm is incorporated in the design, and there is much more space to be seen round the figure. In the print, too, Bueno's right arm is hidden under his fur-trimmed cape.

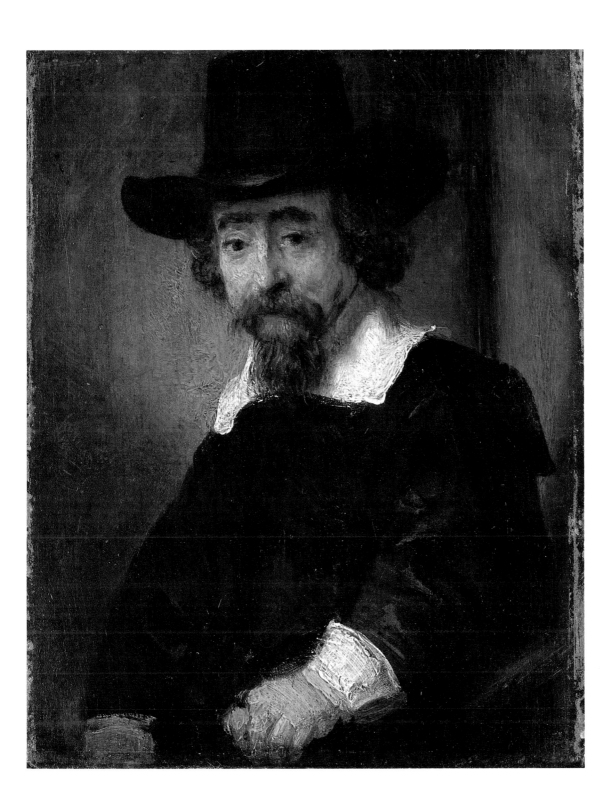

# Nicolaes Bruyningh    1652

No. 33

Canvas, 107.5 × 91.5 cm
*Kassel, Gemäldegalerie*

Nicolaes Bruyningh (1629/30–80) was a young man of good family. In the year in which Rembrandt painted his portrait he had inherited a large fortune from his grandfather; he was then 23 years old. Little more is known of him. He appears to have been a student for some time in Utrecht, but he did not take a degree there. And after 1652, thanks to his grandfather's legacy, he would have had little cause for anxiety about earning his daily living. He died in his fiftieth year, unmarried and without children.

Until 1728 the portrait remained in the possession of his sister's descendants. In 1750 it was bought by Count William VIII of Hesse-Kassel whose collection forms the nucleus of the Kassel museum.

Bruyningh is depicted in a relaxed pose, sitting askew in a chair, with an open collar. He is not looking at the observer, but at something outside the painting to one side. In the background part of a plain wooden chair can be seen, but otherwise the space in which he is sitting has not been worked up. His clothing, too, is not painted in detail, merely indicated. The light shines only on Bruyningh's face, the rest is more or less in shadow. That face, painted with broad, well defined strokes, has enormous vitality, like a snapshot rather than a portrait for which hours had to be spent posing. Wild reddish brown curls, a vague smile round the mouth, somewhat melancholy eyes – Rembrandt was able with few means to give the impression of an encounter with a living person.

Rembrandt's portraits from the 1650s are painted less precisely and with less detail than those from his most successful period as a portrait painter in the 1630s, but it cannot be denied that they have gained in power.

Little is known of the work Rembrandt was doing in the 1650s. He seems to have received fewer commissions. The economic situation in the Netherlands was deteriorating, partly as a result of the war with England; this had repercussions not only on Rembrandt's own finances but also on those of potential patrons. Rembrandt's income diminished, while his debts increased.

# Self-portrait 1652

No 34

Canvas, 112 × 81.5 cm
*Vienna, Kunsthistorisches Museum*

The history of this painting illustrates the dangers of linking the work of an artist to the events of his personal life. Until 1928 this self-portrait was believed to be dated 1656, and people concluded that Rembrandt looked disheartened in it: the painting became symbolic of the great drama in Rembrandt's life which took place in 1656 – his bankruptcy, with the consequent sale of all his possessions, his house, his paintings, his drawings, his etchings and his art collection. But when the picture was restored in 1928 it transpired that it was dated not 1656 but 1652. At that time, in 1652, Rembrandt's financial situation was far from the disastrous state it reached four years later. Having been the portrait of an artist defeated by life, the picture now became the record of a proud, stubborn painter, who, while he was working, as one of his pupils later expressed it, 'would not receive even a king'. That is precisely how over-romantic biographies of Rembrandt pictured him dealing with unwanted visitors, creditors, people requiring complicated commissions, or those in high places for whom he had no time.

The painting must originally have been even more impressive than it is now, because it was once considerably wider; both of Rembrandt's elbows then appeared, before it was cut down on both sides. Perhaps Rembrandt even intended to make it a full-length portrait; at least that is how he appears in a drawing (now in the Rembrandthuis, Amsterdam) which he probably made as a preliminary study for the painting. Beneath it an eighteenth-century collector has written: *getekent door Rembrant van Rhijn naer sijn selves, zoals hij in sijn schilderkamer gekleet was* (drawn by Rembrandt van Rijn of himself, dressed as he was in his studio).

Rembrandt did not make himself more handsome than he was, faithfully recording a rough complexion, wrinkles, the beginning of a double chin. But the eyes, made lively with little highlights, look straight at the observer, with what romantic biographers like to call an 'indomitable' look.

This is certainly an unusual self-portrait, even compared to other self-portraits by Rembrandt, let alone beside self-portraits by other seventeenth-century painters. No dignified pose, no fancy costume – Rembrandt paints himself as if he had just finished working, without embellishment. By dressing himself simply in a brown coat, obviously worn over his everyday clothes, Rembrandt imposed on himself a very limited colour scheme, placing extreme demands on his ability to bring form to the painting. As if to make it still more difficult for himself he chose varied shades of brown for the background.

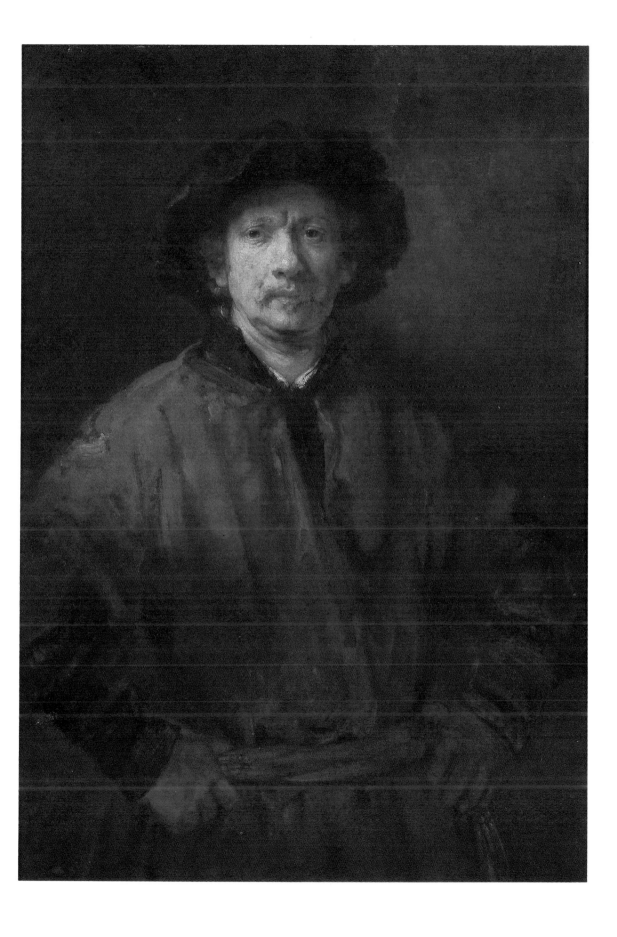

# Aristotle contemplating
# a bust of Homer   1653

No. 35

Canvas, 143.5 × 136.5 cm
*New York, Metropolitan Museum of Art*

Rembrandt's fame reached far beyond the frontiers of the Netherlands, as is clear from a commission Rembrandt received in 1653 from Sicily. Don Antonio Ruffo, a rich art collector in Messina, had conceived the plan of hanging a series of portraits of famous men in his library, and sent to the Dutch painter Rembrandt van Rijn to paint a portrait of a philosopher for the series. Whether it was Ruffo who decided that the philosopher should be Aristotle is not known. For a Dutchman, the choice was obvious. In the Netherlands the classical philosopher *par excellence* was Aristotle, and his work was a compulsory subject in Dutch universities. Rembrandt himself would undoubtedly have studied Aristotle during his years at the Latin school.

Rembrandt portrayed Aristotle in a quite specific role, as tutor to Alexander the Great, to whom, according to tradition, he had taught the art of war with the aid of quotations from Homer. That is why Aristotle's hand rests on a bust of Homer, the blind poet; that, too, is why he is wearing a chain on his chest with a medallion showing a likeness of Alexander the Great.

But apart from these more material reasons for representing Aristotle in this way, Rembrandt may also have meant to represent his basic teachings. Aristotle distinguished three modes of human life, the poetic, the contemplative and the active. The three characters appearing in the picture are representatives of these three modes – poet, philosopher and warrior.

Rembrandt probably painted the bust of Homer from a plaster cast which according to the 1656 inventory he had in his studio. He also possessed a likeness of Aristotle, but what it looked like, and whether he in fact used it for the painting, is not known. In any case Aristotle is not in classical dress; he is in the clothes in which scholars were often portrayed in the sixteenth century – a wide light-coloured garment, with over it a long dark apron, and a wide hat. As for the likeness of Alexander on the medallion, Rembrandt used as a model a medallion then believed to represent Alexander, although it was later shown to be a likeness of the goddess Pallas Athena, armed and helmeted.

In 1654 Rembrandt's painting was ready and it was shipped to Messina. Rembrandt had received his payment, 500 guilders, a year earlier; Ruffo thought it a large sum, and more than an Italian painter would have asked. Other commissions for the gallery of famous men went to the Italians Guercino and Mattia Preti. In 1661 it was Rembrandt's turn again, a commission for a *Homer* (no. 55) and an *Alexander the Great*. Communication between painter and customer did not proceed as smoothly as before: Ruffo was not satisfied with the work the Dutch painter sent him. The matter was never entirely cleared up to the satisfaction of both parties.

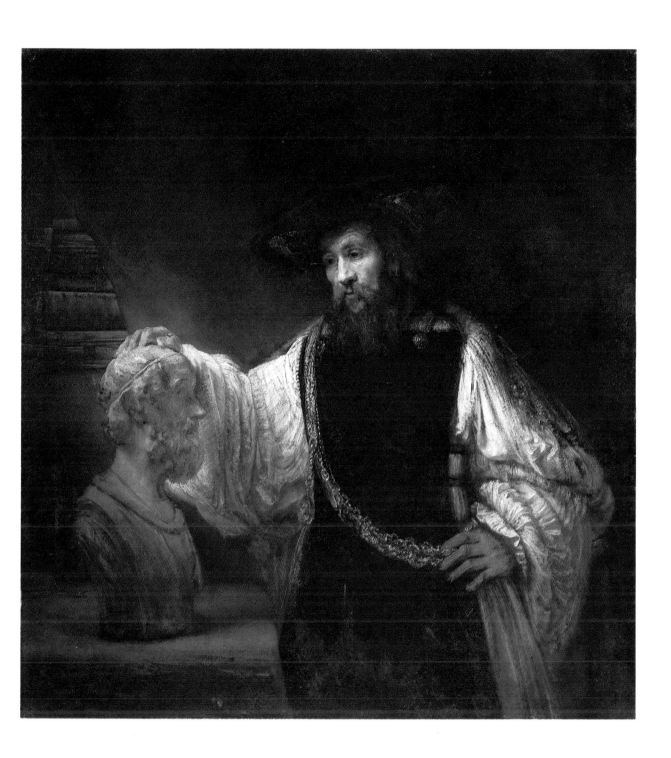

# Bathsheba with King David's letter   1654

No. 36

Canvas, 142 × 142 cm
*Paris, Louvre*

From the roof of his palace King David once saw a very beautiful woman washing herself. Enquiring after the woman's name, and learning that she was Bathsheba, wife of Uriah the Hittite, David invited her to visit him, and lay with her. Later he was to send her husband Uriah into the front line of battle where he perished.

Almost every painter who ever painted the story of Bathsheba chose the moment when David spied on her while she was bathing. But not Rembrandt in this case. His choice fell on the moment of Bathsheba's dilemma: should she obey the king's command – and that weighed heavily in those days – or should she stay faithful to her husband? From her troubled expression it looks as if she already senses the suffering that will result from her decision: the death of her husband, God's reproaches which the Prophet Nathan would pour forth upon David, the death of the first child she was to bear David. X-rays have revealed that at first Bathsheba held her head up more confidently. Only later did Rembrandt choose to make her bow her head in troubled contemplation.

Many drawings are known of naked women who had obviously modelled for Rembrandt and his pupils. Drawing nudes from a model was an important stage in a painter's education, and also for Rembrandt's pupils. These models were no ethereal beauties, but ordinary Dutch women, who could make good use of the money they earned by posing. But Rembrandt also had prints in his collection after paintings by Italians, whose canvases usually represented women of ideal beauty. He put Bathsheba about halfway between the two.

As so often, Rembrandt only indicated the setting in which the action took place, and did not show it in detail. The brilliant, gold-coloured bedspread is striking. Using a sophisticated technique, Rembrandt has us see that the bundle of white linen on Bathsheba's left is a white sheet with a white shift lying upon it; the sheet is reproduced with thin, broad strokes, while for the shift the paint is applied more thickly and densely.

Rembrandt avoided anecdotal detail, so he showed David's letter face downwards. As such it contributes to the atmosphere of the painting. But Rembrandt knew how to show unmistakably that it was a letter: the folds in the paper can still be seen, and one corner of the paper is curled up, so that the writing on it is visible.

The old serving woman is wearing an unusual large flat hat, covered with large loops of cloth, the sort of hat which in those days was used for the depiction of oriental women.

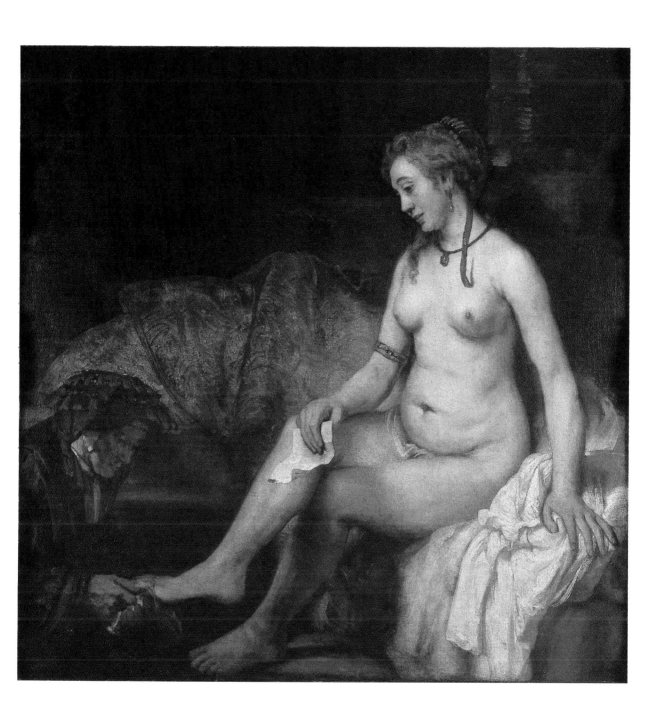

# Jan Six    1654

No. 37

Canvas, 112 × 102 cm
*Amsterdam, Six Foundation*

Jan Six (1618–1700) owned and ran a large dye works for cloth and silk in Amsterdam, which his grandfather had founded. In 1652 Six decided to retire from his partnership in the dye works in order to devote himself exclusively to his duties as a regent, and to his intellectual interests, art collecting and writing verse. In 1691, at the age of 73, Six was burgomaster of Amsterdam for a year. He lived in a handsome house on the Kloveniersburgwal, and had a country retreat on the Amstel.

Rembrandt produced a number of works for Six. In 1647 he made a full-length portrait etching of him, standing by a window with a book in his hands. The next year he etched an illustration for *Medea*, a play by Six, representing Jason's marriage to Creusa. In 1652 Rembrandt sold Six three paintings which he had made in the 1630s, a portrait of Saskia and two religious pictures. In the same year Rembrandt twice made a contribution to Six's *Album Amicorum* (Book of Friends) which seems to indicate that there was more than a business relationship between them.

When Rembrandt needed money in 1653 to pay his creditors, Jan Six was one of those who lent to him, providing 1000 guilders. Just a year later Rembrandt painted this portrait of Jan Six, perhaps to pay off his debt in kind.

The portrait of Jan Six has been called the most beautiful portrait ever painted, combining style with psychological insight. Jan Six is 36 years old, a man of the world, well read and with wide interests. The portrait is not static, but catches Six in a moment of action: he has just drawn on his left glove, and gives the impression of being on the point of departure. Rembrandt has reinforced the impression of immediacy by the manner in which he painted the picture, quickly and confidently. The gold embroidery on the red coat is just a series of strokes of paint, done with a broad brush; the glove shows little detail, whereas the right hand is strikingly rendered, even the tension in the hand necessary to draw on the glove is made visible.

The attitude of the head is not that of any ordinary sitter: Jan Six is looking at the observer rather enquiringly, his head slightly on one side, without posing or vanity, but with the justified hesitation of someone encountering a stranger. Because the portrait is approximately life-size, the spectator inevitably feels as if he or she were face to face with a living man. This is Rembrandt at his best, a portrait that is true to life without being an accurate reproduction in all its details.

After more than three centuries, the portrait is still in the ownership of Six's descendants.

# A woman, possibly Hendrickje   *c*1655

No. 38

Canvas, 72 × 60 cm
*Paris, Louvre*

There are many paintings in Rembrandt's oeuvre which on the one hand look like portraits, but on the other give an impression of intimacy with the sitter which goes beyond that of a normal commission. Such paintings have often been identified as someone close to Rembrandt, in the Leiden years his brothers, sister, father or mother, in his Amsterdam period Saskia, Geertje, or Hendrickje; boys as Titus, girls as Cornelia (the daughter of Rembrandt and Hendrickje).

It is impossible to verify these identifications, however. Even where a documented portrait exists, as in the case of Saskia, it is still difficult to establish convincingly that women in other pictures seeming to resemble her really represent her.

In the seventeenth century making a portrait of the members of one's own family was probably less common than we might think. The nineteenth century provides an image of the artist using his intimates, his wife, his mistress, his friends, his sister or his landlady, repeatedly as models. In the seventeenth century the use of an officially engaged, professional model was the normal procedure, which would probably have held good for Rembrandt as for other painters. Especially for nude studies a seventeenth-century painter would almost invariably have used a professional model rather than someone he knew personally.

Rembrandt the buccaneer, who did not give a damn for any conventions of society, has become a popular character in all kinds of books and even films. But this is Rembrandt seen through nineteenth-century spectacles, an image formed when artistic genius seemed synonymous with social nonconformity. There is no reason to assume that Rembrandt in fact displayed eccentric traits.

This is one of many paintings by Rembrandt difficult to classify: is it a portrait or is it the head of a woman, any woman, painted for the open market? Does it represent some specific person, or is it a study for its own sake? The most convenient answer would be that it is a portrait of Hendrickje, who probably joined Rembrandt's household in 1649, and who evidently quickly ousted Geertje from Rembrandt's favour. In 1654 she bore him a daughter.

The woman in the picture is informally but richly dressed, with a fur coat, expensive jewellery and an elegant coiffure with ringlets round her ears and red ribbons to hold the hair up. It looks rather too elegant an outfit for the simple Hendrickje. On the other hand, Rembrandt often portrayed himself decked out in a costume very different from that of everyday reality, so why should he not have done the same with Hendrickje?

# Woman bathing    1655

No. 39

Panel, 61.8 × 47 cm
*London, National Gallery*

This painting appears to have been painted directly from the life: the woman is rendered without artifice, and particularly the way in which she lifts up her shift to stop it getting wet is strikingly natural. But the surroundings in which Rembrandt has placed the woman, the wealth of red and gold hangings, with their reflections in the water, give the impression that more is intended than a true-to-life picture of an everyday occurrence.

The painting might be a study for Susannah, who in the Old Testament was spied on by two Elders while she bathed, or for Bathsheba with whom King David fell in love when he saw her bathing. The rough way in which it is painted is like that generally used for a sketch, a preliminary study. But no worked-up painting of a subject like this is known, and the fact that Rembrandt signed it with his full signature leads one to suppose that he considered it to be a finished painting.

The sketchiness of the painting is shown, for example, by the woman's left hand: seen from close up there are only a few streaks of paint, although from a distance the gesture of lifting up the material, the light bend of the wrist, and the pressure of the fingers bent backwards are clearly recognisable.

The woman's shift is painted in a few quick broad strokes. In a few places the layer of white paint is applied so thinly that the darker base layer can be seen beneath it, creating a shadow. Rembrandt has shown palpably that the material of the shift is coarse, a thick linen which falls heavily over shoulders and breasts, and makes wide folds where the shift is held up.

Brilliant, too, is the reflection in the water, with little white edges of light in the water where the woman is wading through the pool, and little ripples in the foreground, as if the water was splashing gently against the bank there. Rembrandt has represented the normal seventeenth-century way of bathing, when it was not usual to bathe naked.

It is assumed that in planning and executing his paintings Rembrandt hardly ever made use of artificial aids, of drawn or painted sketches. He thought up the painting in his head, making use of the enormous arsenal of images and impressions stored there, and only began to give actual shape to the image on the canvas or panel itself, where he sketched the picture in strong outlines and then filled it in section by section. It is difficult to fit this painting into that method of working. It is unique in Rembrandt's oeuvre.

# Titus at his desk    1655

No. 40

Canvas, 77 × 63 cm
*Rotterdam, Boymans-van Beuningen Museum*

Titus van Rijn was born in 1641. He was the only one of Rembrandt and
Saskia's four children not to die in infancy. His mother Saskia, however, died
a year after he was born. His nurse then became Geertje Dircx, a widow in her
mid-thirties, whose relationship with his father Rembrandt quickly became a
close one. However, after some seven years Geertje and Rembrandt quarrelled
and Geertje's place in the household was taken by Hendrickje Stoffels, at the
time of her arrival some 23 years old. She remained with Rembrandt and Titus
until her death in 1663.

We do not know by documentary proof what Titus looked like. But it is quite
likely that the boy and later the young man with the narrow white face and curly
brown hair who appears repeatedly in paintings, always at an age consistent
with Titus's age at the time, is Titus. These paintings are usually not strictly
portraits, far from it: Titus seems often to have posed as a model for an invented
person or scene.

Since Titus, too, was to be a painter, he will often have sat like this with his
father in his studio, pencil in hand, pencil case dangling from his desk, gazing
pensively in front of him over the pages of his sketchbook. No work by Titus
van Rijn is known now, but some are recorded in Rembrandt's inventory, and
also elsewhere. Since none of it has survived, nothing is known of its quality.

In this painting, Titus would have been fourteen. At that age boys intended
to be artists had often already started their apprenticeship with a master painter.
But for Titus this time would not have been free from care. In the following year
all his father's possessions were to be sold, even Titus's own works. And just
a few years later he had to apply for a declaration that he had attained his
majority, so that he could start up in business with Hendrickje as an art dealer:
Rembrandt himself was no longer permitted by the guild to sell his work, once
having been made bankrupt.

As so often Rembrandt has shown nothing of the surroundings in which
the boy is placed. He has only, very boldly, placed the desk straight across the
picture, between Titus and the observer. The brown colour of the desk is a
brilliant harmony of many shades of brown, here and there brought to life by
minuscule points of light. The pencil case hanging from it is almost tangible, a
deliberate *trompe-l'oeil* – a display of technique of which seventeenth-century
painters were very fond. Titus supports his chin on his thumb, looking pensively
into the distance with wide dark eyes, with one eyebrow rather more raised than
the other: rarely has contemplation been so strikingly depicted.

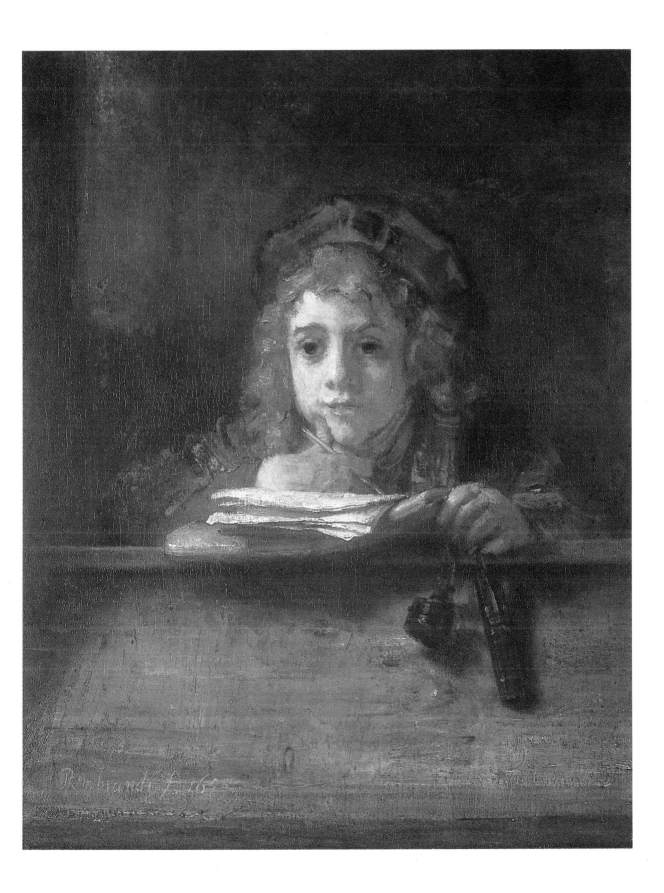

# Jacob blessing the sons of Joseph    1656

No. 41

Canvas, 175.5 × 120.5 cm
*Kassel, Gemäldegalerie*

As an old man Jacob had followed his beloved son Joseph into Egypt, where Joseph, having been sold into slavery by his jealous brothers, had made a brilliant career for himself. When famine afflicted his native Israel, he lovingly received his eleven brothers and his aged father in Egypt.

When Jacob, who had become old and blind, felt his end approaching, he let it be known that he wanted to bless Joseph's sons. According to Jewish tradition he had to bless the eldest, Manasseh, with his right hand, and the youngest, Ephraim, with his left. But Jacob decided otherwise: he laid his right hand on the head of Ephraim. When Joseph pointed out his mistake to him, he said, 'I know it, my son, I know it; but Ephraim shall be greater than Manasseh, his seed shall become a multitude of nations.'

From earliest times Jacob is represented in Christian art blessing with his arms crossed: the eldest son Manasseh stands on Jacob's right, but Jacob crosses his arms to bless Manasseh with his left hand. In most cases, too, Joseph tries with a gesture to correct his father's mistake. But in Rembrandt's painting the argument between father and son is over; Joseph is supporting his father's gesture of blessing. In art Joseph's wife Asenath is almost never present, and the Bible does not mention her. But Rembrandt could not picture such an event without their mother being present, looking thoughtful and affected by emotion.

The story of Jacob's blessing was later seen as a prophecy of the future of the Christian church. Ephraim was one of Christ's ancestors, and in blessing him Jacob was blessing the Christians. Therefore Rembrandt represents him as a fair-haired boy.

Rembrandt chose a theatrical setting for the scene, with dark curtains on either side, and light falling on the picture from behind the curtains. The red blanket spreads out to occupy the whole foreground and creates a distance between the events and the observer.

As always Rembrandt has paid great attention to the dress of his figures: Joseph very oriental, with his large, carefully wound turban, and Asenath, the Egyptian woman, with a headdress that is indeed of Egyptian origin, but which Rembrandt had derived, like Asenath's retiring pose, from a medieval sculpture.

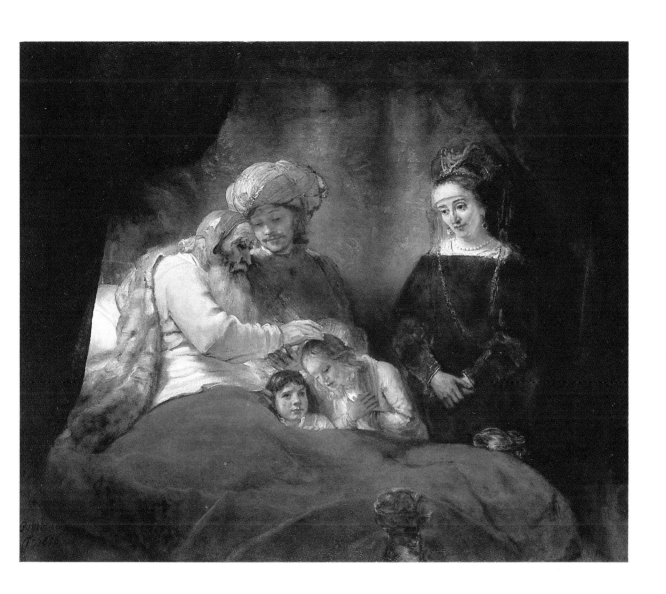

# The anatomy lesson
# of Dr Joan Deyman   1656

No. 42

Canvas, 100 × 134 cm
*Amsterdam, Rijksmuseum (*on loan from the *City of Amsterdam)*

Dr Joan Deyman succeeded Dr Nicolaes Tulp as *praelector anatomiae* in 1653.
Tulp had had one of his public lectures on anatomy painted by Rembrandt
(no. 10), so Deyman, too, decided to have this done: Rembrandt painted the
lecture Deyman gave on 29 January 1656 and the days immediately following, on
the body of an executed criminal, Jan Fonteyn, who had been sent to the gallows
the day before for burgling a draper's shop, and threatening those trying to
arrest him with a knife.

In 1723 there was a fire in the Theatrum Anatomicum in the Weighhouse on
the Nieuwmarkt. Many of the contents were saved, but *Dr Deyman's anatomy
lesson* by Rembrandt was irreparably damaged. Only about a quarter of it was
spared, and even there the traces of the fire were apparent.

In the painting Deyman was demonstrating an aspect of the structure of
the brain. Only the professor's hands are still visible. His assistant, Gijsbert
Calckoen, stands next to the body, holding the crown of the skull. Rembrandt
was better informed about the procedure than in the 1632 anatomy lesson; this
time he shows that the stomach cavity is empty and that all the contents subject
to putrefaction have been removed.

Rembrandt's composition was bold. The body was seen from straight in front,
foreshortened, an idea that he had perhaps taken over from Italian examples in
which the body of the dead Christ was shown in this way. How the picture
originally looked is known from a sketch (now in the Rijksprentenkabinet,
Amsterdam) which Rembrandt made of it, perhaps to indicate what kind of
frame the painting ought to have. It reveals that the group of observers was
placed symmetrically round the body and Dr Deyman, a design which could
easily have become somewhat dull, but which Rembrandt undoubtedly knew
how to turn into a lively composition. An example is the way the right hand of
Calckoen, the assistant, is depicted, with the palm turned outwards; the light
falls on the hand in such a way that it almost looks as if one could grip the
fingers.

1656 was the year of Rembrandt's bankruptcy, despite this important and
lucrative commission from the Surgeon's Guild. It was for a big painting, some
275 × 200 cm, and all those portrayed each paid for their portraits. To judge by
the drawing there were eight of them, not counting the assistant, so it was a
commission involving several hundred guilders.

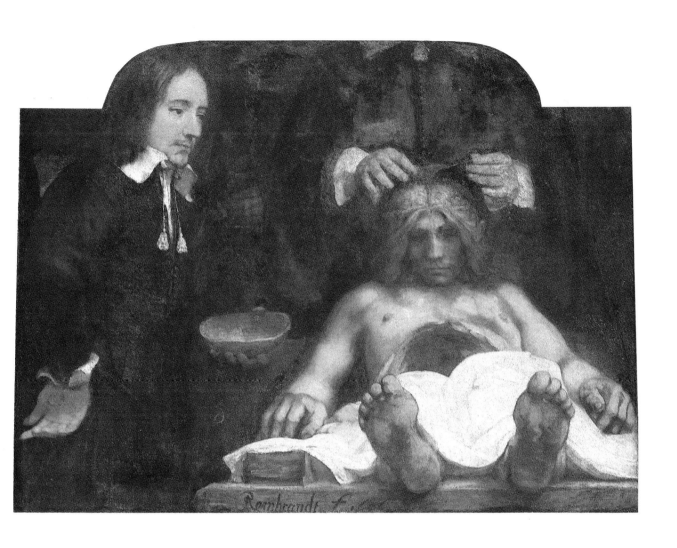

# A woman, perhaps Hendrickje, at an open door  *c*1656

No. 43

Canvas, 88.5 × 67 cm
*West Berlin, Staatliche Museen*

This painting, which is generally regarded as a portrait of Hendrickje, is undoubtedly inspired by Venetian art, in which half-length pictures of women in relaxed attitudes were a popular subject. It is similar, for instance, to a painting by the Venetian Palma il Vecchio auctioned in the 1640s by Gerrit van Uylenburgh (Hendrick's son). Thanks to the fact that on Rembrandt's bankruptcy in 1656 a comprehensive inventory was made of his possessions, which has survived, Rembrandt is known to have owned a considerable store of Italian pictures, particularly prints. Besides, Rembrandt, as he had done on the occasion of Lucas van Uffelen's sale (see no. 26), made sketches at every opportunity of paintings he came across.

X-ray photography has shown that Rembrandt decided on the position of the hand on the doorpost only at his second attempt. Previously the woman looked rather more forwards, and had her hands folded in her lap. The final composition, with the slightly sideways pose, the inclination of the head, the surprising detail of the hand on the post which still catches the light, is undoubtedly more interesting.

If this painting in fact represents Hendrickje Stoffels, then she must have been about 30 at the time. She had joined Rembrandt's household some seven years earlier, probably as a domestic help for Geertje Dircx. Not much is known about her. She came from Bredevoort, a small town in the Achterhoek, a district quite close to the frontier with Germany. Her father was a sergeant, and her brothers soldiers. At Bredevoort there was a permanent garrison. As the Eighty Years War came to an end, and campaigning was over, most of those in military service settled down. Many soldiers married local girls, as Hendrickje's father, Stoffels Jegher, married her mother, whose name is not known. The position of sergeant required some education, the ability to exercise authority, and preferably also to read and write; a sergeant's pay was about twice as much as an ordinary soldier's. Hendrickje herself, like so many girls at that time, could not write; on documents she signed herself with a cross.

Why Hendrickje went to the great city of Amsterdam is not known. She is first mentioned in 1649, as a witness in a quarrel between Rembrandt and Geertje, and was then in service with Rembrandt. She stayed there until her death in 1663. From being a servant she soon became Rembrandt's mistress. The church council lectured her for her behaviour in 1654, but in vain; Cornelia was born the same year. In 1660, after the bankruptcy, Titus and Hendrickje set up a company, as a device to enable Rembrandt to go on selling his pictures. Rembrandt never married Hendrickje, although she is described in documents as his *huysvrou* (wife).

Hendrickje is always described as caring, faithful and loving, but these adjectives are not founded on any authority. However, if one assumes that this and similar portraits represent her, then the description is quite understandable.

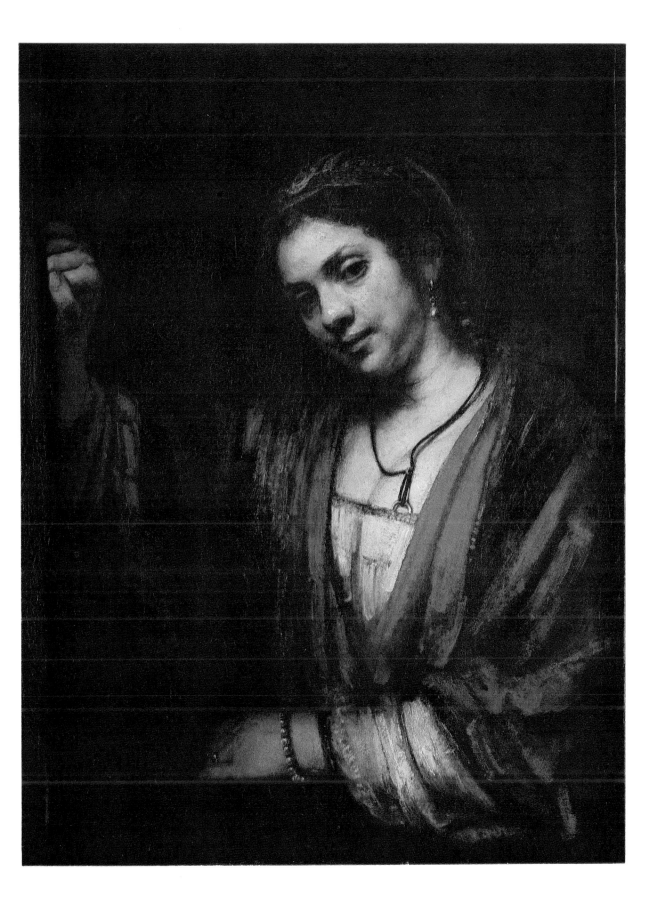

# Self-portrait 1658

No. 44

Canvas, 133.7 × 103.8 cm
*New York, The Frick Collection*

In his youth Rembrandt had decked out himself and his models with the most fantastic costumes, and from the inventory of his possessions it appears that he was also an enthusiastic collector of these party props. Sometimes it is plain what he means to say with these brilliantly dressed up figures, and who they represent – a prophet, an Old Testament character, an apostle, or a Roman goddess. But more often the exact meaning of these fanciful costumes is uncertain.

The question is even more difficult in the case of a self-portrait. Is it indeed a self-portrait in the literal sense of the word, or did Rembrandt want to depict some specific character – a philosopher, a saint, a historical figure – but used his own likeness to do so? Sometimes his characters look as if they have escaped from a theatrical performance, and the theatre of that time has often been searched for parallels to Rembrandt's paintings – mostly in vain, since Rembrandt is not generous with clues, and also because information on seventeenth-century theatre is, at least as far as costume is concerned, rather limited.

This self-portrait is an 'unsolved' picture. It shows a princely figure; the sturdy body is wrapped in a yellow-gold garment that looks as if it has been made for a grand occasion, with a loosely wound red sash with a finely worked tassel, a gold-embroidered collar, and a white kerchief round his throat. Over all is a wide cloak of fur or velvet. His right hand rests on the arm of a chair; in his left hand the man holds a cane (a sceptre?) with a shining knob on top, his wrist resting on the other arm of the chair. The cap with its scalloped edge had been one of Rembrandt's favourite attributes since his self-portrait of 1640 in Italian style (no. 26).

The portrait is the more impressive because the man is portrayed three-quarter length and the observer has to look up at him. His cap throws a shadow on the forehead, but the fierce brown eyes, unmistakably Rembrandt's eyes, look straight at the observer; that wide nose, tight mouth – it is unmistakably Rembrandt.

Rembrandt's personal circumstances that year seem to have been completely the opposite of those shown in the portrait. In 1658 the third sale of his property took place, and all his possessions, his house, his furniture, his works, his art collection, were now sold. But the proceeds, some 17,000 guilders, were not enough to satisfy his creditors. It was plain: Rembrandt would have to leave his fine house, and look for more modest rented accommodation elsewhere in the city. The move took place in 1660; Rembrandt, Hendrickje, Titus and Cornelia went to live in the Rozengracht, in a house that was at most only half as large as that on the Sint Anthoniebreestraat. Rembrandt had to start all over again. But he went on painting, with the same dedication, with the same pursuit of something more and more striking, more and more true, with more and more concentration on the essence of the picture.

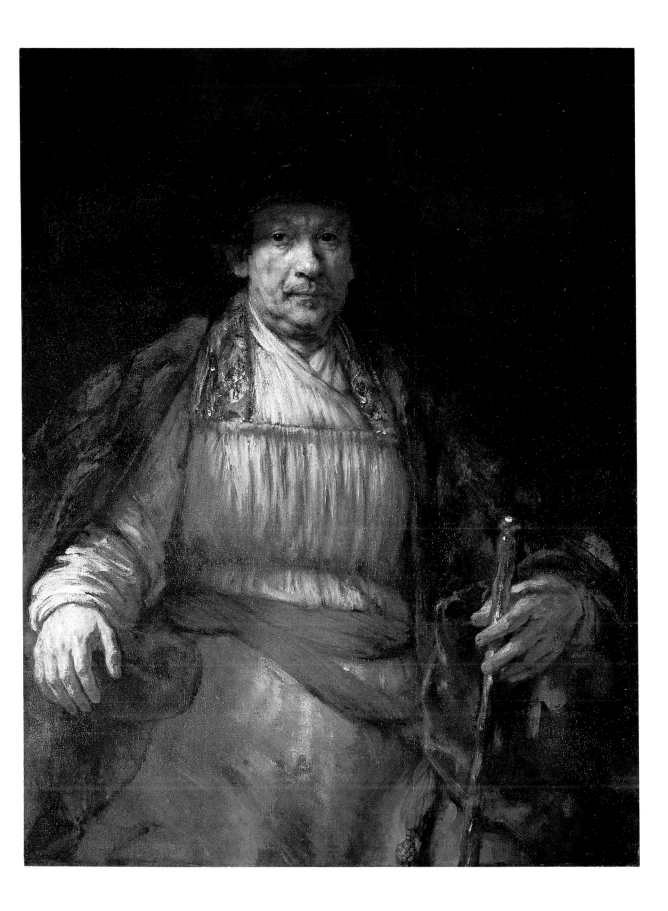

# Titus in friar's habit    1660

No. 45

Canvas, 79.5 × 67.5 cm
*Amsterdam, Rijksmuseum*

Titus was not a friar. But it is not surprising that Rembrandt decided to paint his son in a Capuchin's habit. All the gradations of brown, which Rembrandt liked so much, were to be found in it. And just as Rembrandt in the past had successfully rendered the black clothing of his patrons in a harmony of many tones, so here he could render all the nuances of brown, the deep shadows, the highlights, the differences in tone, in such a way that no detail of the habit's construction is unclear.

A habit of this kind isolates the sitter's face from the background; all attention can therefore be concentrated on the face, Titus's pale, narrow face, introspective, his eyes cast down. Probably Rembrandt did not intend a portrait of his son in a friar's habit, but was using him as a model for a picture of St Francis of Assisi, who even in the predominantly Protestant Netherlands was a popular saint. Not only Catholics but also Protestants felt the appeal of the story of the man who, as the son of a rich cloth merchant, gave up all his possessions to devote himself for the rest of his life to the sick and the poor. The Order which St Francis had founded, whose friars dressed in brown habits, sandals on their bare feet, devoted to a life of poverty, living from alms, split in the ensuing centuries into a number of separate Orders. One of them, the Capuchins, became particularly strong in the northern Netherlands, where it was established in 1585. Even after the Protestant church had acquired control almost everywhere, the Order still continued with its work on a restricted scale. Rembrandt would undoubtedly have been familiar with these followers of St Francis from his own observation.

Titus is here just nineteen, a pale fragile-looking young man. It is assumed that Titus, like his mother, suffered from tuberculosis, and that that is why he always looked so vulnerable. He was only 27 when he died, seven months after his marriage to Magdalena van Loo, a niece of Titia, his maternal aunt. Their daughter was born six months after his death, and was also called Titia.

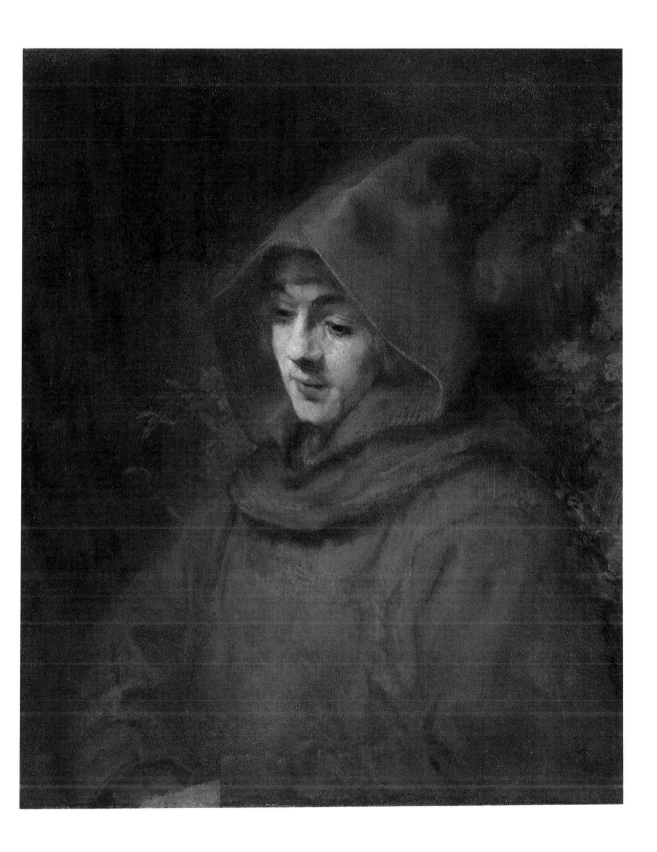

# The Denial of St Peter    1660

No. 46

Canvas, 154 × 169 cm
*Amsterdam, Rijksmuseum*

Jesus was arrested on the orders of the priests and taken to the palace of
Caiaphas the High Priest, there to be judged. He was accused of claiming to be
the Messiah, which was blasphemy in the eyes of the priests and the scribes.
Questions of blasphemy had to be judged by the highest religious authorities.

Peter, one of Jesus's disciples, followed the party, and went into the court of
the High Priest's palace, joining the soldiers who sat round the fire there. A
maid-servant recognised him by the light of the fire as one of Jesus's disciples,
but Peter denied it. Then another said 'Thou art also of them' but again Peter
denied it, and when a third said 'Surely he was one of them', Peter burst out,
'Man, I know not what thou sayest'. Then the cock crew, and Jesus, who was
inside before the High Priest, turned and looked upon Peter, who remembered
that Jesus had foretold that before the cock crew he would deny him thrice.
Peter went out and wept from shame and remorse.

Rembrandt chose the third, last denial for his painting: in the background
Jesus looks at Peter. But Rembrandt wanted to depict particularly the interaction
of the two protagonists: the sensation-mongering serving-maid holding her
candle a bit closer to Peter's face, and Peter denying, gesturing widely with his
left hand, with his right hand on his heart. Two soldiers, dressed in armour
which reflects the light of the fire, look on with interest.

Rembrandt's picture strongly recalls the work of the Utrecht Caravaggists,
who, following Italian example, employed many variations of the effects of
candlelight in their paintings. Rembrandt used the idea with his usual subtlety:
the candle itself is not visible, but it is quite plainly there, hidden by the maid-
servant's right hand, but shining its light on the most important part of the
painting, Peter's flat denial – the same Peter who until shortly before had been
considered the most faithful of the disciples, and who received the name Peter
(Greek for 'rock') as the rock on which the Church would be built.

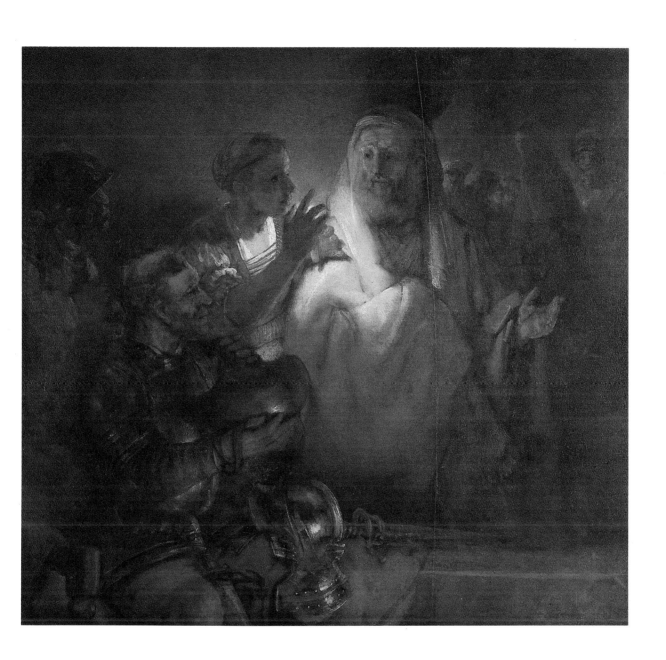

# Self-portrait as St Paul  1661

No. 47

Canvas, 91 × 77 cm
*Amsterdam, Rijksmuseum*

St Paul is one of the most enigmatic characters in the New Testament. At first a zealous persecutor of the Christians, afterwards he became, by God's intervention, equally zealous in proselytizing for Christianity. After his conversion Paul made long missionary journeys throughout Greece and Asia Minor, wrote ceaseless letters to the various Christian communities, and was eventually to pay for his labours with his life: he was beheaded in Rome in AD 64. Since then an executioner's sword has been one of his attributes. Because in this painting Rembrandt has the hilt of a sword in the folds of his cloak, it is assumed that he is depicted here as St Paul.

Rembrandt portrayed St Paul several times as an old man with a grey beard imprisoned by the Romans, but still writing his epistles, included also in this self-portrait. The characters on the pages look like Hebrew; Rembrandt would not have known that St Paul wrote his epistles in Greek.

St Paul's work was of great importance for the foundation of the Christian church. His epistles not only interpreted the Gospels for the Gentiles, but also encouraged them to form congregations and provided them with rules and a common doctrine. His writings were still much read and discussed by the Christians of Rembrandt's time, particularly among the Mennonites, the denomination to which Rembrandt probably felt himself to be most closely attached – though little is known of Rembrandt's religious convictions.

Perhaps the self-portrait as St Paul was intended as one in a series. In any case a number of paintings exist from this same period of more or less the same size, all depicting apostles. How precisely the series was made up, whether it was ever completed, or whether perhaps some of the paintings from it have been lost, is not known.

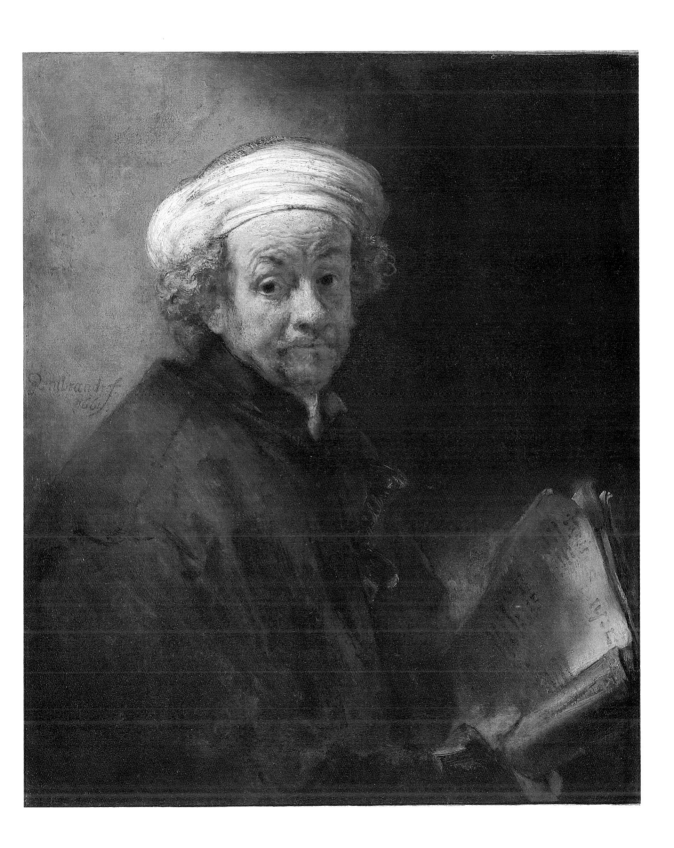

# A man holding gloves   *c*1660

No. 48

Canvas, 99.5 × 82.5 cm
*Washington, National Gallery of Art*
Pendant of no. 49

Even in this period of Rembrandt's life, so different from that of his great society successes in the 1630s, he was still in demand as a portrait painter, and a portrait like this, of a still unidentified man, looks at first sight very like his portraits of some 25 or 30 years earlier, with its relaxed pose and unadorned background. Amsterdam patrons were still normally dressed in black, though collars were now flat, and it had become the fashion to let part of the shirt-sleeve protrude from the sleeve of the coat.

This portrait has none of the flamboyance that characterised the portraits of the 1650s, of Jan Six (no. 37), or Nicolaes Bruyningh (no. 33). By contrast, it more closely resembles the conservative work of the portrait painters who were newly in vogue, Ferdinand Bol, Rembrandt's former pupil, and Bartholomeus van der Helst. But Rembrandt's mastery shows even in an apparently traditional portrait by the impression of instantaneity given: the man has raised his right hand, but it looks as if he is about to let it fall again; he is glancing at the observer, momentarily, as if about to glance away again.

The treatment of light, always Rembrandt's *forte*, helps to strengthen the impression of immediacy. The broad-rimmed hat shadows part of the face. In fact only a quarter of the face is at all brightly illuminated, by the light coming from behind his left shoulder. That light falls inside the bend of his right arm so that the hand and cuff stand out from the background and throw shadows on the cuff of the other hand, but the light still falls on the thumb of that hand where it holds the gloves. It is the positioning of these hands, with their animated movement, that makes this picture more than a run-of-the-mill portrait.

The portrait is a pendant to another of an unknown woman (no. 49); several other portraits from Rembrandt's later period remain unidentified.

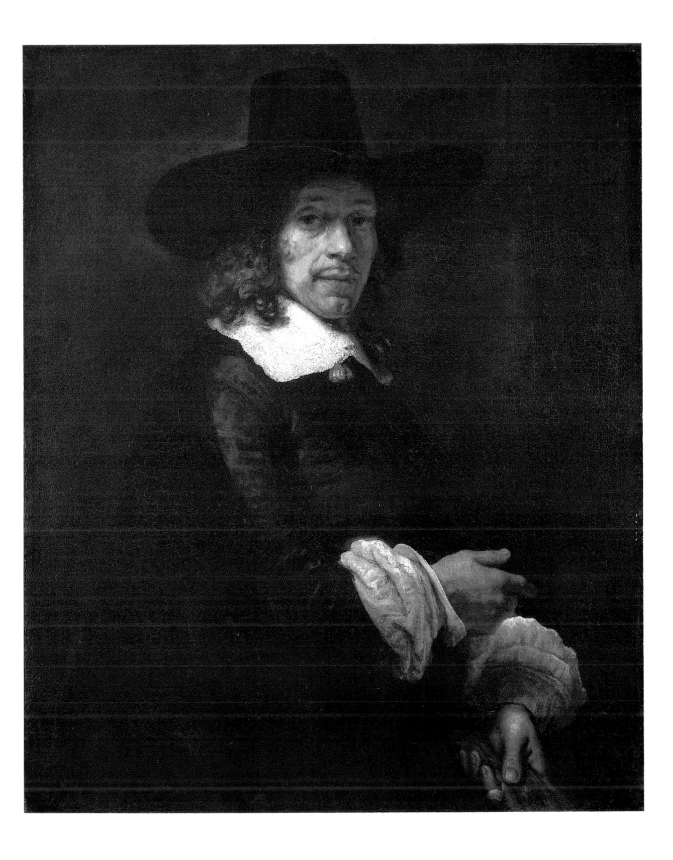

# A woman holding an ostrich feather  *c*1660

No. 49

Canvas, 99.5 × 83 cm
*Washington, National Gallery of Art*
Pendant of no. 48

While the husband (no. 48) is turned to the left, his wife is shown almost fully
frontal, her body turned a little away from her husband, but her face turned
rather more in his direction. She is looking not at the observer, but composedly
into the distance with unusually big brown eyes. She radiates a quiet chic. She
is dressed in an up-to-date fashion, in a modern collar of fine linen with a wide
edge of lace falling far over the shoulders, pleated at the back, so that it stands
up a little in the neck; she has wide sleeves with wide white cuffs, two handsome
gold bracelets, and in her hand a loose ostrich feather which appears not to have
a handle and so is not for use as a fan. Ostrich feathers, imported from Africa,
were used both for decorating hats and caps and as fans.

In this portrait, as in that of the man, Rembrandt manages superbly to give
the impression that the picture just catches a passing moment – the mouth just
open, the lower lip protruding slightly, the clear glance. This is not a woman
who has sat posing for hours. She has, just now, loosely folded her hands,
hardly a pose she could have held for long. But one must assume that even for
Rembrandt painting a portrait involved at least a few hours posing; if only from
a technical point of view a portrait of this kind would have required considerable
time.

These paintings are, contrary to Rembrandt's normal practice, unsigned and
undated. Opinions therefore differ about when they were made. From the look
of the sitters' clothing the portraits appear to fit well into the early 1660s.

After 1661 Rembrandt worked under the new arrangements for the sale of his
work. Hendrickje and Titus sold all Rembrandt's paintings, prints and drawings
through their art dealing business, provided him with the materials to work with,
and paid his board and lodging. Rembrandt also collected pictures during these
years, but what he collected, too, became the property of the company. He had
to work in a house that was appreciably smaller than that on the Sint
Anthoniebreestraat. One must assume that he also had a studio elsewhere,
because there are still a number of large paintings dating from the 1660s. In
1661 he even received a commission for the largest painting he ever made,
one to decorate the Amsterdam Town Hall (no. 53).

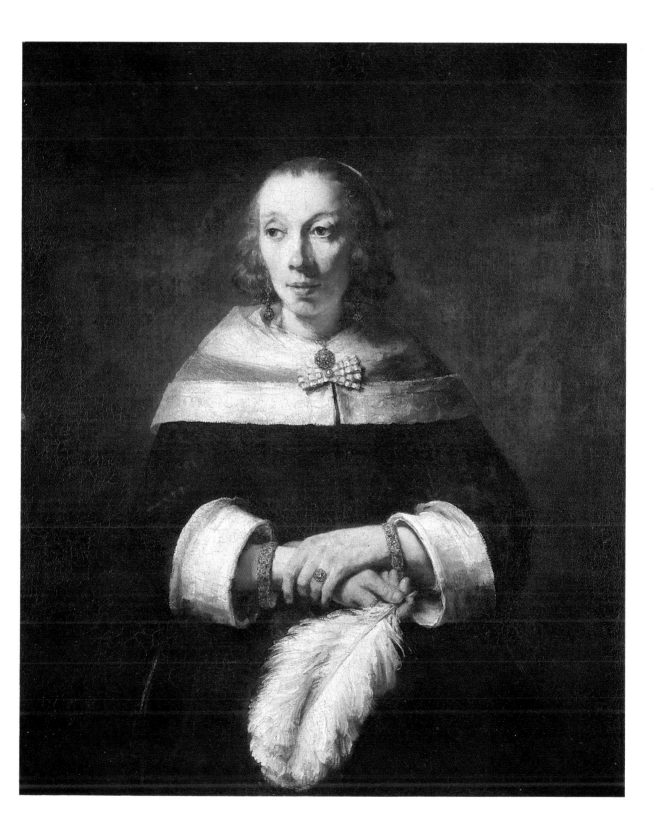

# Self-portrait   c1661–62

No. 50

Canvas, 114.3 × 95.2 cm
*London, Kenwood House, The Iveagh Bequest*

Rembrandt portrayed at his profession as a painter is a rare occurrence. In this self-portrait he has his right hand in his coat pocket, but in his left he holds his palette, his brushes and his maulstick.

The light falls from above left, illuminating one side of the face, with a spot on the nose, and leaving the rest of the body in shadow. The light also falls on the wall behind the painter, an unusually light background for Rembrandt. There are two circles drawn on the white-washed wall, so strikingly that they must be there for some reason.

But what reason? The most probable is a reference to Apelles, Alexander the Great's renowned court painter, to whom later painters were commonly compared: 'the Dutch Apelles' was an enviable title. The story was told, and often represented in pictures, that Apelles fell in love with Alexander's mistress Campaspe, who had posed for a painting of the goddess Aphrodite. Alexander thought so highly of his painter that he gave Campaspe to Apelles – a princely accolade which still rang like music in the ears of seventeenth-century painters.

Another story about Apelles, but one which never, as far as is known, was painted, relates that Apelles went to the island of Rhodes to visit another famous painter, Protogenes, but found him not at home. Instead of leaving a message Apelles drew a line on a blank panel standing in the studio. When Protogenes returned he immediately understood who his visitor had been, since only Apelles could have drawn such a perfect line, and he replied to the message in the same way. The third move was Apelles's, when he visited Protogenes a second time, saw the panel with the two lines, and drew a third line, freehand, which perfectly bisected the first two.

The story does not relate what sort of lines Apelles and Protogenes drew in their game without words, but it was later suggested that they must have been circles, for what is more difficult to draw freehand than a perfect circle?

Had Rembrandt this story in mind when he painted this self-portrait? Was he comparing himself to Apelles, and about to draw the third line, precisely between the two other circles? If Rembrandt is declaring himself to be the Dutch Apelles, he is setting himself up as the equal of the greatest artist in history.

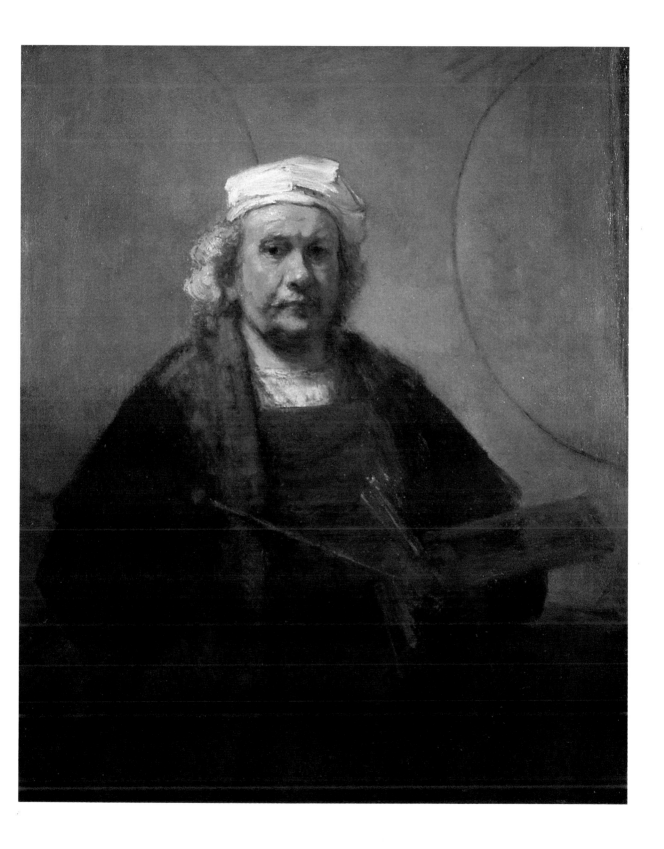

# Jacob Trip   *c*1661

No. 51

Canvas, 130.5 × 97 cm
*London, National Gallery*
Pendant of no. 52

In the 1630s Rembrandt had been commissioned to make two paintings of members of the Trip family, one of the widow of Elias Trip and one of her daughter Maria (no. 23). In 1661 there came a commission from Hendrick Trip, the son of Elias's brother Jacob. Together with his brother Louis, Hendrick had built an impressive house on the Kloveniersburgwal, or rather two identical houses behind one façade, one for Hendrick, and one for his brother. On the roof of the house they placed chimneys shaped like mortars, in homage to the arms trade which had made them wealthy. Probably for the adornment of these premises Hendrick commissioned a number of portraits. Family portraits on the wall gave status, and showed that a man had some history behind him. Hendrick had his own and his wife's portraits painted by Ferdinand Bol, a pupil of Rembrandt who was then very fashionable, but chose Rembrandt himself for the portraits of his parents. Jacob Trip (*c*1575–1661) and his wife Margaretha de Geer (she was a sister of Lodewijk de Geer, his partner in business; his brother Elias and son Hendrick were also married into the De Geer clan, so keeping the money in the family) were already advanced in age when Hendrick made the commission. They still lived in Dordrecht, where the business had originally been started. Whether Rembrandt travelled to Dordrecht, or whether Jacob and Margaretha came to Amsterdam, perhaps to have a look at their son's new house, is not known. It may even be doubted whether Rembrandt was able to make his portrait of Jacob from life, since the sitter died in the same year of 1661, as early as 8th May; Rembrandt may have had to use an already existing portrait as a model. That also might explain why the portraits of husband and wife are so different from each other.

In the portrait Jacob is dressed informally, wearing a kind of dressing gown and a little skull cap. Gowns of this kind were often worn at the end of the seventeenth century, particularly by artists and scholars; there are a great many portraits of that period in which the sitters are dressed in them. Foreigners often found it a strange sight when these gowns were worn out in the streets, and there is even the story of a foreign visitor who wondered whether the Dutch were perhaps commonly ill. It may have been the normal dress for a man of Jacob Trip's 87 years.

Elias and Jacob were born in Zaltbommel, but moved to Dordrecht, where they started a business based on their father's iron trade, which quickly expanded enormously. The firm of De Geer/Trip was a business of European importance, involving not only iron mines and arms factories, but financial dealings and trade virtually in everything. The wars which in those years caused continual unrest in Europe worked to their advantage; all sides were good customers of De Geer/Trip.

In 1614 Elias moved to Amsterdam, where he was one of the wealthiest citizens. His style of life, however, remained a sober one. His brother Jacob stayed in Dordrecht, but his three sons, all involved in the business, eventually established themselves in Amsterdam.

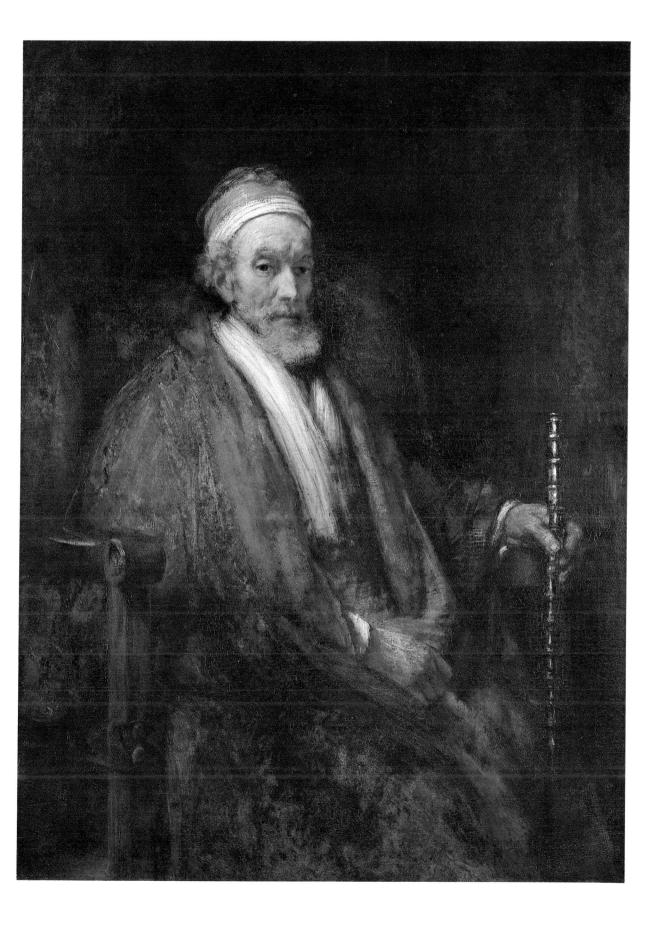

# Margaretha de Geer    *c*1661

No. 52

Canvas, 130.5 × 97.5 cm
*London, National Gallery*
Pendant of no. 51

Margaretha de Geer (1583–1672), wife (or perhaps already widow) of Jacob
Trip, was aged about 78 when Rembrandt painted her portrait. That was
already a great age by seventeenth-century standards, but she died aged 89.
She was a woman of spirit, as can plainly be read from her portrait. Jacob and
Margaretha de Geer were extremely rich, but particularly from Margaretha's
portrait it seems that, like so many of the wealthy Dutch, they were averse to a
display of their wealth. Money was there to be invested, not to show off with. So
no costly jewellery for Margaretha Trip, no expensive lace; and like many elderly
women of the period Margaretha did not keep up with fashion in her dress. She
had worn much the same sort of clothes as this black dress with a black fur-
trimmed overdress, and a big 'millstone' ruff, her whole life long. On her hair
she wears a little black cap, which may be a sign that she was already a widow
when her portrait was painted. The handkerchief in her right hand is an
attribute often used in portraits particularly of older women.

Probably in the same year Rembrandt painted another portrait of Margaretha
Trip (also in the National Gallery, London), half length, and seen more from
one side, but again in the same kind of costume. The second portrait may have
been destined for one of her other children.

The portraits of Jacob and Margaretha de Geer were two of the first paintings
Rembrandt made under the new company rules. Hendrickje and Titus supplied
him with the materials to produce his paintings, gave him board and lodging,
and in return Rembrandt delivered all his paintings to the company, who then
sold them on to the purchaser or patron. In this way Rembrandt's income was
kept secure from his creditors.

In 1661 Hendrickje became ill, and obviously for that reason decided to
regulate the future of the company in a will. In the long will, which she signed
with a cross, she named her daughter Cornelia as her heir with Rembrandt as
guardian. The company would continue under Titus, who was designated as
Cornelia's heir.

When Hendrickje died two years later (she was buried on 24 July 1663)
matters were arranged accordingly. Since she was then only 41, it is assumed
that she died of the plague which in 1663, in Amsterdam alone, claimed 1752
victims. Titus's death in 1668, and that of his wife Magdalena van Loo in 1669,
are also ascribed to the plague.

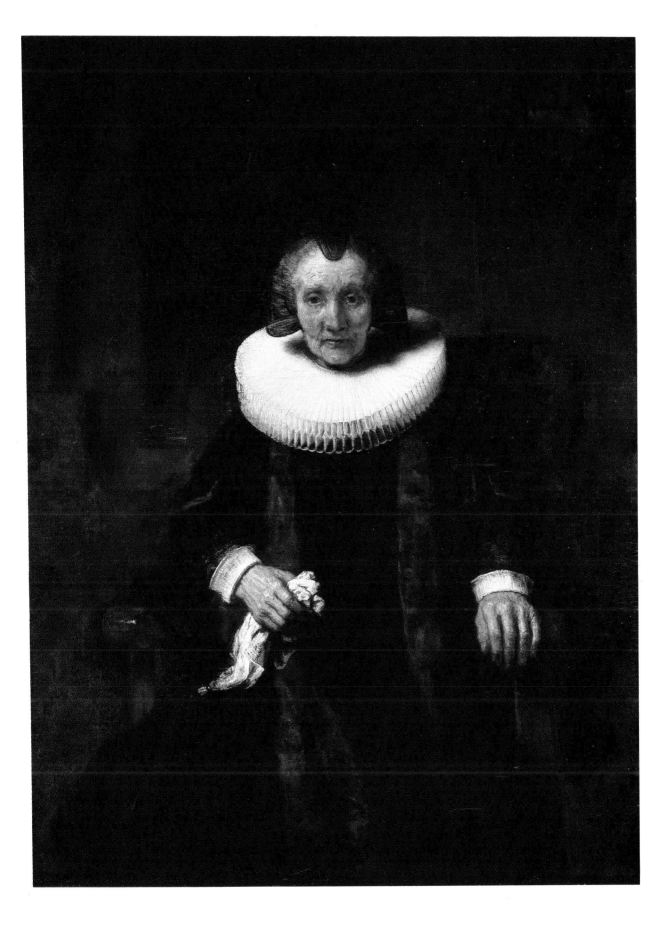

# The oath of conspiracy
# of Claudius Civilis   c1661–62

No. 53

Canvas, 196 × 309 cm
*Stockholm, Nationalmuseum*

In the summer of AD 69 Claudius – also called Julius – Civilis (at least that was what the Romans called him, among his own people he no doubt had another name) decided to free his people, the Batavians, from Roman rule. Under the pretext of a sacrificial feast he called the leaders of the people together in a sacred grove. There he spoke so convincingly of the iniquity of their subject status that as one man they swore an oath against the Romans, initiating the Batavian Revolt, which was successful at first, but finally failed in AD 70. The Dutch in 1660 saw a parallel between the Batavian Revolt and their own successful struggle against Spain. When the decoration of the Amsterdam Town Hall – now the Royal Palace – on the Dam came to be discussed, episodes from the Batavian Revolt were chosen as subjects for the paintings in the central gallery. The commission went to Govaert Flinck, but he had hardly started on the pictures when he died. The commission was then divided among a number of painters, Rembrandt being allocated the subject of the *Oath of the Batavians.* The picture was to be 5.5 metres square, and was destined for the east corner of the gallery.

In 1662 one Melchior Fokkens wrote a book about Amsterdam, in which he gave a description of the decorations in the Amsterdam Town Hall. He refers to a painting of the *Oath of the Batavians* by Rembrandt in the south-east corner of the great gallery. But in 1663 a picture by the painter Jurriaen Ovens was placed in that section, also depicting the *Oath of the Batavians.* What had happened? Did Fokkens anticipate events, and was Rembrandt's painting never hung? Or was Rembrandt's painting removed immediately after it was hung, and replaced by the Ovens, which still hangs there now?

In 1891 it was discovered that a painting in the Stockholm Nationalmuseum, called the *League of the Bohemian General Ziska,* was in reality the middle section of Rembrandt's *Oath of the Batavians.* Only a quarter of the original composition has survived, and the whereabouts of the rest are unknown. The overall design is known only from a rapid sketch Rembrandt made on the back of an announcement of the death of one Rebecca Vos, who was buried on 25 October 1661: six steps lead up to a great vaulted hall in which Claudius Civilis is sitting with a group of Batavians at an enormous table.

According to the legend Claudius Civilis had only one eye, and so is clearly identifiable in Rembrandt's painting. For the composition, Rembrandt undoubtedly took account of the fact that the painting was to hang in a dark corner at least seven metres from the ground. For this reason he depicted the scene from below, with the figures in front of the table screening the source of the light on it, so that the picture is illuminated mysteriously out of the darkness. It looks almost as if the light were shining out of the table itself, because it is reflected in the swords that the Batavians clash against each other in their common oath.

This was a great commission but was never completed – either because his patrons were not satisfied, or because Rembrandt did not succeed in delivering on time a painting which complied both with their ideas and his own.

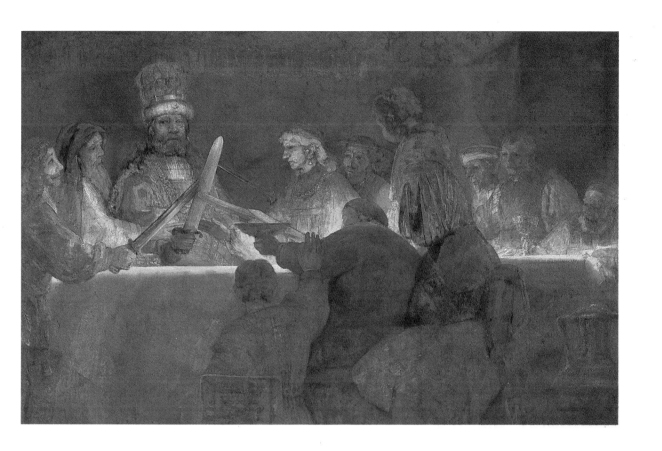

# The 'Syndics' (*Staalmeesters*) of the Amsterdam Drapers' Guild 1662

No. 54

Canvas, 191.5 × 279 cm
*Amsterdam, Rijksmuseum (*on loan from the *City of Amsterdam)*

The *Staalmeesters* of the Drapers' Guild exercised control over the quality of baize cloth that was traded in Amsterdam. Baize is a fine woollen material, now used almost exclusively for covering billiard tables, but in the seventeenth century cities like Amsterdam or Leiden to a great extent owed their prosperity to the baize industry.

In 1661 the Amsterdam Staalmeesters of the day – they served for a year from Good Friday to Good Friday – decided to have their portraits painted. The painting was to hang in the Staalhof, the hall where they held their sessions; the building still stands in the Staalstraat in Amsterdam. The idea of a portrait was actually the revival of an old tradition. A number of group portraits of Staalmeesters hung in their hall, but almost all dated from the sixteenth century. The place for the new painting had already been settled – quite high, possibly above a mantelpiece or a wainscot panel.

The commission for the portrait went to Rembrandt. He first made separate drawings of all the Staalmeesters, two of which are still extant (in Amsterdam and Rotterdam). To group six people round a table, in such a way that they did not appear stiff and wooden, was a problem with which many painters had wrestled before Rembrandt. Rembrandt, too, obviously found it difficult. From X-ray photographs of the picture it appears that he made considerable alterations. For instance, the servant, the man without a hat, first stood more to the right, and Rembrandt altered the pose of the man half rising from his chair at least three times.

Knowing that the painting would be hung high, Rembrandt selected his viewpoint so that the table is seen in the correct perspective only when the painting hangs above eye level. The Staalmeesters then look down on the observer naturalistically. Rembrandt also dramatized even this rather limited subject of six men dressed in black behind a table. The men look up from their work as if they had been disturbed by an unexpected visitor during their weekly meeting.

In front of them on the table lies the subject of their labours, the sample book, in which everything about the baize they inspected was recorded.

The painting over the mantel shows a beacon with a fire blazing, in reference to the essential qualities which the Staalmeesters required, watchfulness and vigilance.

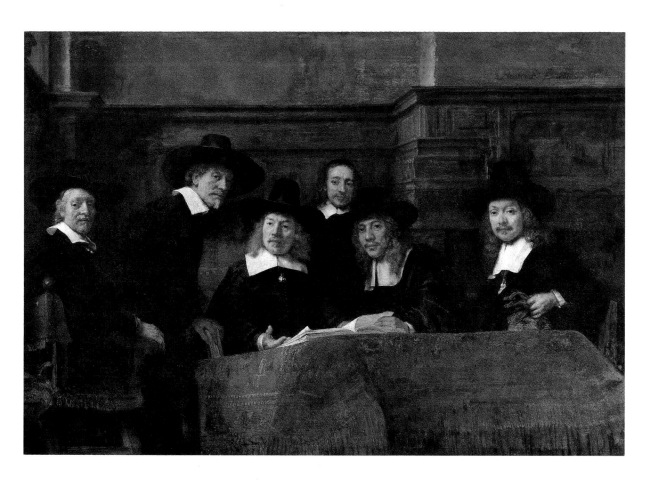

# Homer 1663

No. 55

Canvas, 108 × 82.4 cm
*The Hague, Mauritshuis*

Homer, the poet of the *Iliad* and the *Odyssey*, was, according to tradition, blind, and this is also how Rembrandt portrayed him. As his model he took a well-known Hellenistic bust of the poet that he had already used in his painting of Aristotle (no. 35).

The Sicilian aristocrat Don Antonio Ruffo had obviously been satisfied with Rembrandt's *Aristotle*, since in 1661 he came up with another commission, this time for a *Homer* and an *Alexander the Great*, perhaps with the idea of hanging them on either side of the Aristotle. There were all kinds of complications with the *Alexander* right from the beginning, creating dissatisfactions on both sides which were never entirely cleared up. It is also uncertain which painting should be regarded as Ruffo's *Alexander*; two are known, and it is also possible that the original has been lost.

Things went better with the *Homer*. As early as 1661 the painting travelled to Messina in a half-finished state to obtain Ruffo's approval of the design. In 1664 it was finished, Ruffo had his painting and Rembrandt his money. The picture which was hung in Messina was larger than the *Homer* now in the Mauritshuis in The Hague, since the right-hand section of the painting was lost apparently in a fire in the eighteenth century. Fortunately there is a drawing by Rembrandt (Stockholm, Nationalmuseum) showing the full composition: a second man, a pupil or a secretary, is sitting on the right, taking down Homer's words.

The *Iliad* and the *Odyssey*, Homer's two epic poems, date from some time in the eighth century BC. The *Iliad* describes part of the siege of Troy by the Greeks, the *Odyssey* is about the wanderings of Odysseus, one of the heroes who had fought against Troy; after Troy fell he had to voyage for ten years before he could return home to Ithaca.

Even in antiquity doubts had been expressed whether the poet Homer had really existed, and the question is still not settled. The *Iliad* and the *Odyssey* were almost certainly poems handed down orally, and at some later time written down, perhaps indeed in several different versions. Did a Homer ever come into that process? If there was a Homer, was he in fact blind? There are after all many passages in the poems that could only have been written by someone who had sight.

Reading Homer in the original Greek was restricted in the seventeenth century (as now) to a small group of scholars, but the stories of the *Iliad* and the *Odyssey* were well known. Anyone who, like Rembrandt, had attended the Latin school would certainly have heard them. Rembrandt also knew that Homer's poems did not rhyme, unlike most of those of our own or Rembrandt's time, but had a fixed metre. Rembrandt therefore portrayed Homer with his right hand beating out the rhythm of the lines he was dictating.

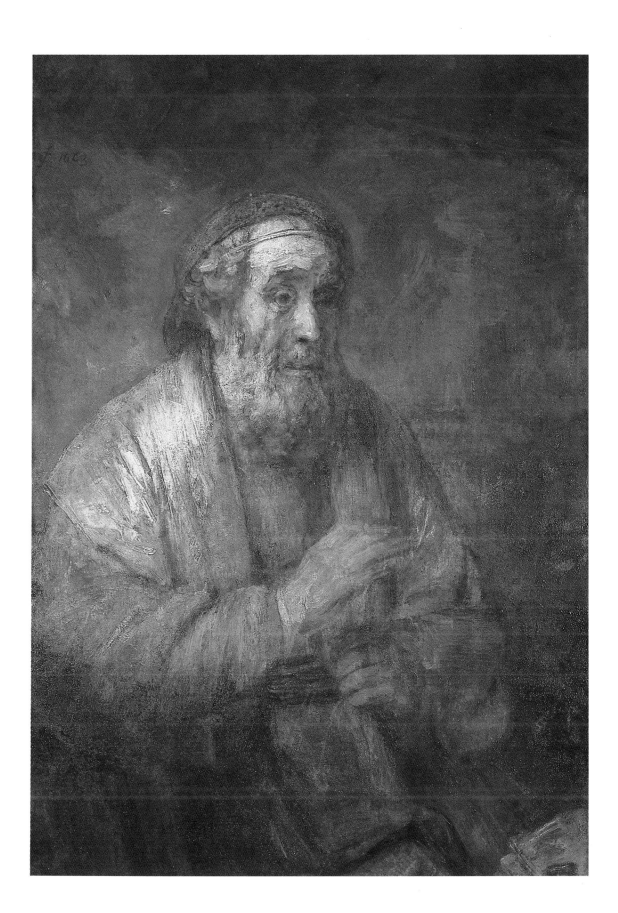

# Frederick Rihel 1663

No. 56

Canvas, 282 × 248 cm
*London, National Gallery*

When Frederick Rihel, born in 1625 or 1626, an Amsterdam merchant, died in Amsterdam in 1681, unmarried and without issue, he left no will. The contents of his house on the Herengracht were therefore sealed so that an inventory could be made of them. Rihel had been wealthy, judging by the inventory. His property included much silver, porcelain and paintings. One of these paintings was *het conterfijtsel van de overledene te paert door Rembrandt* (the portrait of the deceased on horseback by Rembrandt).

It was extremely rare in the Netherlands for anyone to have their portrait painted riding a horse, especially in a painting of this size. But Frederick Rihel had an international background: he came originally from Strasbourg, and his commercial and financial affairs were worldwide. From his inventory it appears, too, that Rihel was a man who liked outward display, since it describes so many fine pieces of clothing and coloured fabrics, decorated with fringes and lace. He was also a keen horseman. When he could afford it he kept his own stable; he insisted that his successive manservants should be able to handle horses. At his death in 1681 he possessed two dapple-grey horses in a stable on the Reguliersmarkt, plus a coach and an open carriage.

In 1660 William III, then ten years old, had paid a state visit to Amsterdam. One hundred and eight Amsterdam cavaliers rode in the prince's train, in three groups; the young prince's coach travelled between the second and third groups. Frederick Rihel was a member of this third group, riding immediately behind the prince's coach. This is the event commemorated by Rihel's portrait by Rembrandt. Behind the horseman, in the background, is revealed the coach and in a patch of light the profile of the young prince.

Rembrandt's portrait of Frederick Rihel is life-size, and is his largest painting after the *Night Watch*. Its size is successfully matched by its grandeur. Rihel also possessed other portraits of himself of smaller size: the 1681 inventory mentions *dito conterfijtsel daer hij te voet gaet* (ditto portrait, on foot) and a *conterfijtsel van de overledene in gesnede vergulde lijst* (portrait of the deceased in a carved gold frame).

It has sometimes been thought that the horse in Rihel's portrait was not by Rembrandt himself, since thereby the least successful part of the painting – the rather stiff horse – would be transferred to the account of a less talented master. But the case that another hand was involved has not yet been convincingly demonstrated.

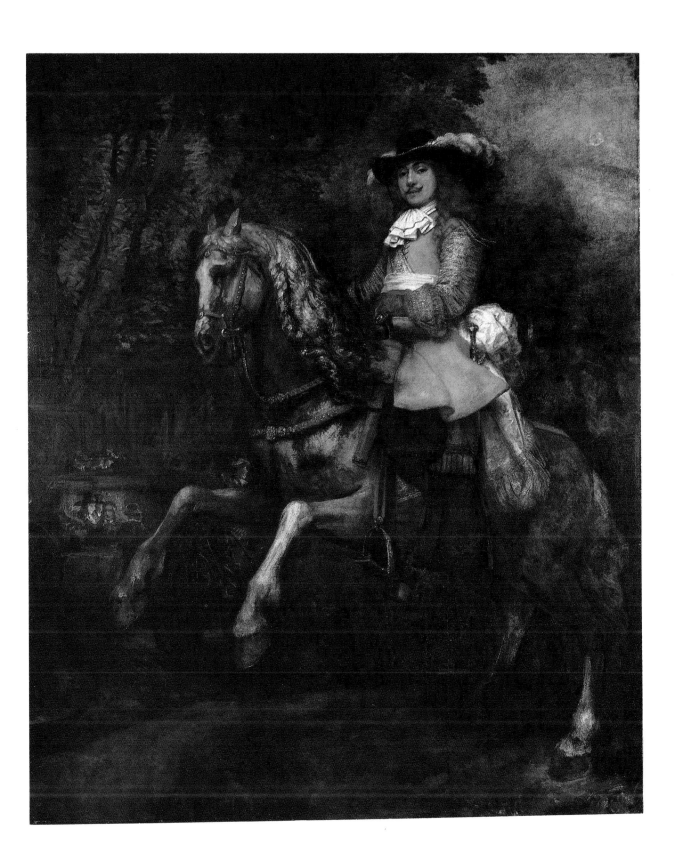

# Juno  *c*1662–65

No. 57

Canvas, 127 × 107.5 cm
*Los Angeles, The Armand Hammer Foundation*

The goddess Juno (known in Greek as Hera) is not a sympathetic figure in Greek or Roman mythology. She appears as a jealous wife: there are numerous stories of how she tried to thwart her husband, Jupiter, the supreme god, in his continual love affairs. Jupiter was usually too clever for her, for he was a master of disguise, whether as a bull, a swan, or a shower of gold, and his activities soon filled the Olympian heaven with gods and goddesses, demigods and demigoddesses. The sympathies of the narrators of mythological stories obviously lay more often with Jupiter. However, Juno was the highest ranking goddess, sister to Jupiter as well as his wife; she was superior to all the other goddesses in power and distinction.

It is this Juno, the regal consort, whom Rembrandt has portrayed in his painting. With her crown, her mantle of ermine, the many strings of jewels over her breasts, the fully frontal pose, her right hand supported on a staff, she is as regal as a figure could be – 'Juno Regina'. Her glance, calm and imperturbable, is that of a queen.

That we have Juno here, and not the figure of some other queen, is plain from the peacock just to be seen bottom left, Juno's invariable attribute. According to the legend, it had Juno to thank for the eyes on its feathers. She had sent the many-eyed giant Argus to watch Io, one of Jupiter's mistresses. But Jupiter sent the god Mercury to sing and play to Argus such sweet music that all his eyes closed as he fell asleep, when it was simplicity itself for Mercury to kill him. Despite the fact that Argus had not achieved his task, Juno rewarded him, placing his many eyes on the tail of her favourite bird, the peacock.

In 1665 Harmen Becker, a wealthy collector, with whom Rembrandt had argued previously about money, complained that a *Juno* he had ordered was not yet ready. It is not known whether this was the painting involved.

It looks as if Rembrandt took as model for his Juno a painting of about a century earlier: the way in which the woman is posed, full face, is typical of sixteenth-century paintings of important people such as saints or princes. But the style of painting is unmistakably Rembrandt. No single part of the painting is worked out in detail, everything is merely indicated. Even so, the image he evokes in this way is as true to life as any meticulously painted sixteenth-century model it might have had.

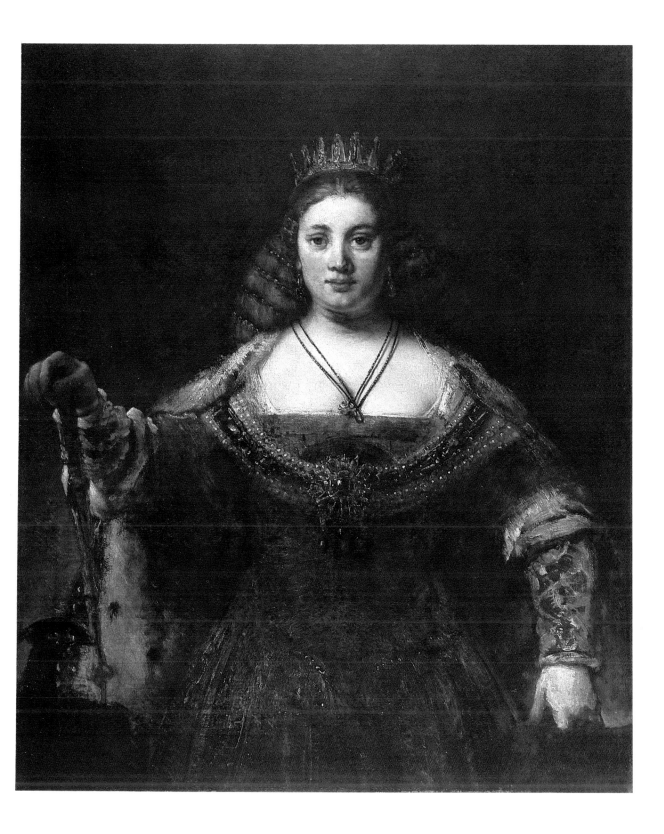

# 'The Jewish bride'  *c*1662

No. 58

Canvas, 121.5 × 166.5 cm
*Amsterdam, Rijksmuseum* (on loan from the *City of Amsterdam*)

This painting acquired the title of the 'Jewish bride' in the early nineteenth
century when someone saw in the picture the story of a Jewish father who hung
a chain round his daughter on the occasion of her wedding. Nowadays the man
in the painting is no longer believed to be her father, but her lover, bridegroom
or husband, and whether the couple are Jewish is very questionable. But the
name 'Jewish bride' has become so generally accepted that it will probably
always be linked with this painting.

What is the painting of? In view of the couple's extraordinary dress it cannot
be simply a portrait of a man and a woman in seventeenth-century Amsterdam,
even on their wedding day. But their faces give the impression of being portraits.
Are they perhaps a married couple dressed like a couple out of the Bible, or in
some theatrical scene? All kinds of suggestions have been reviewed in the last
few years, but none of them yet seems sufficiently convincing.

But clearly this is a brilliant illustration of two people's mutual love, she shy,
he dominant and protective. Hands often play an important role in Rembrandt's
work; gestures are never without meaning, even in Rembrandt's portraits. Here
they play the principal role, the girl lightly touching with her left hand the man's
right, which he has placed over her heart, an ageless gesture of love.

The paint itself gives texture to the material of the couple's clothing.
Rembrandt used a palette knife instead of a brush to apply the gold on the man's
sleeve with thick strokes which reflect the light, and in the woman's red dress
some parts are laid on so thickly that the paint itself creates light and shadow.
The man's coat consists of several layers of paint not only applied but also
scratched and scraped to give the effect of cloth of gold. Rembrandt has carefully
reproduced the nature of the different kinds of material, whether fine and almost
transparent, or stiff, falling in broad folds, gathered or pleated.

The background is, as so often, kept dark. Some sort of construction can be
vaguely seen, some suggestion of trees, all absorbed in the brown of the
background.

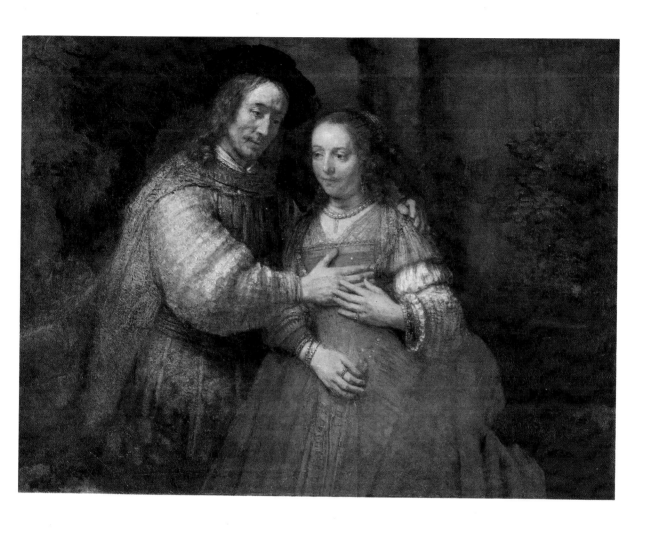

# A family group  c1663–68

No. 59

Canvas, 126 × 167 cm
*Brunswick, Herzog Anton Ulrich Museum*

Family groups are no rarity in Dutch seventeenth-century painting, indeed there was a taste at that time for intimate, even cosy scenes. What could be more intimate than a father and mother with their children at home?

The greatest problem in painting this kind of group portrait was that of creating a unity, showing people realistically as a group reacting to each other. It could be done through the composition but also by making people touch one another, making children play together with something, or offer something to another, a flower or an apple. Rembrandt used all these methods: the father is about to offer his little daughters a flower, the girls themselves appear to be having a discussion across the basket of flowers, while the infant has his left hand on his mother's breast, and the mother is looking with great tenderness, her head slightly inclined, at her youngest child. But Rembrandt has made this a group portrait like no other, because he could evoke an impression of spiritual contact between the sitters that transcends their gestures.

He needed no pleasant room in a Dutch household to depict intimacy: it is hardly possible to see where this family is. Its members are, as so often, not wearing contemporary clothes; the girl on the left looks like a Renaissance princess, and the father has an unusual coat with no collar. The infant on his mother's lap is a boy, despite his dress, since in the seventeenth century boys usually wore dresses until they were four. He is marked as a boy by his feathered cap and the chain hanging across his chest.

The happy family is so informally represented that it was once assumed they were from Rembrandt's own close environment, a family from among Titus's in-laws perhaps. Titus was married on 10 February 1668 to Magdalena van Loo, a niece of his aunt Titia. The Van Loos had been friends of Rembrandt for years. Titus died that same year, perhaps from the same plague that took Magdalena a year later.

In the last years of his life Rembrandt often apparently would no longer finish his paintings. At least, when in late 1668 the young Prince Cosimo de' Medici and the painter Pieter Blaeu visited Rembrandt's studio, they found to their surprise not a single completed painting. Whether Rembrandt would have regarded some of them as finished or not is another matter. He no longer needed to work out forms in detail to give expression to an idea or a feeling.

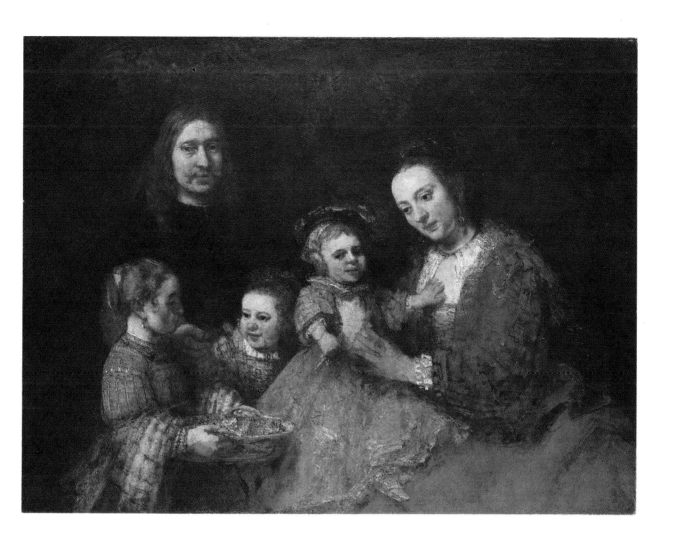

# Self-portrait    1669

No. 60

Canvas, 63.5 × 57.8 cm
*The Hague, Mauritshuis*

Rembrandt signed and dated this portrait clearly and in full, Rembrandt 1669, as he had been accustomed to do since the 1630s. It was to be his last self-portrait, and indeed almost his last painting. But there is no sign that his powers are failing him, in his appearance, his technique or his signature. In September 1669 Rembrandt had had a visit from the painter Allaert van Everdingen and his son Cornelis, who make no mention of sickness or the frailty of old age. His death on 4 October 1669 must have been sudden. He was buried four days later in the Westerkerk; his coffin had sixteen bearers, which shows that it was no pauper's burial. The location of the grave in the church is not known.

Rembrandt was 63 when he died and had more than 40 years of painting behind him, in a life of much grief and adversity. His spirit remained unbroken to the end – or that is the kind of comment this portrait seems inevitably to provoke.

After his death an inventory was made of his belongings and effects in the house on the Rozengracht. Three rooms were sealed up and their contents not listed, since they contained Rembrandt's paintings and his art collection which belonged, in accordance with the contract of 1660, to Hendrickje and Titus's company and were thus the property of their heirs, Cornelia and little Titia. This note in the inventory suggests that Rembrandt had again built up an art collection in the second half of his life; unfortunately this time there is no record to tell what the collection contained.

The 1669 portrait is as surely and powerfully painted as the portraits of the 1650s. Rembrandt made only one later alteration, the gold-coloured stripes on the white cap, the better to make it harmonize with the finely painted background, the grey hair and flesh tones of the face. Rembrandt's style of painting had lost nothing in quality. But the way he painted no longer suited contemporary taste. People wanted cool, evenly painted pictures of elevating subjects, and that is precisely what Rembrandt's paintings were not. Nearly two centuries had to pass before Rembrandt was again widely recognised as a painter of genius, the painter who surpassed all his contemporaries. The recognition would have pleased him. Had he not always striven to paint differently, better and with more perceptive vision than his contemporaries, yes, even to equal and surpass his famous predecessors?

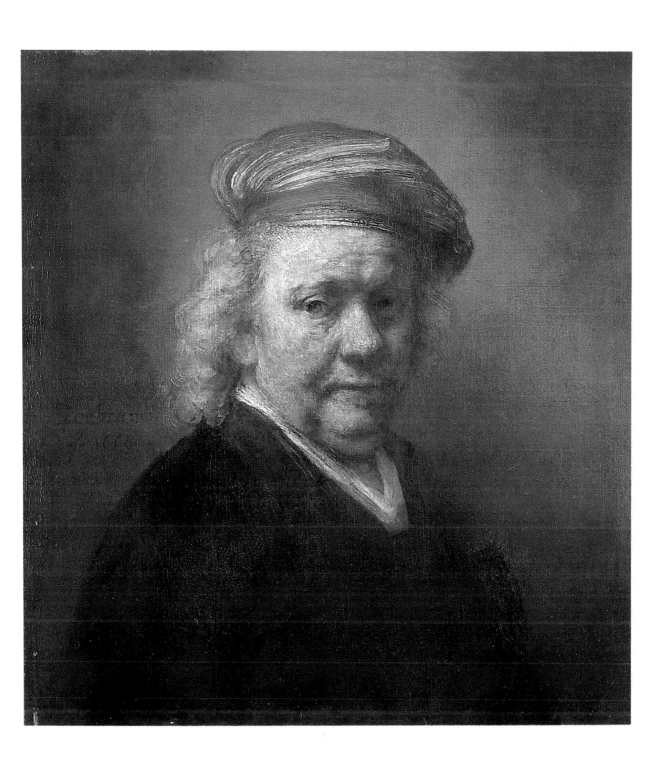

# Index